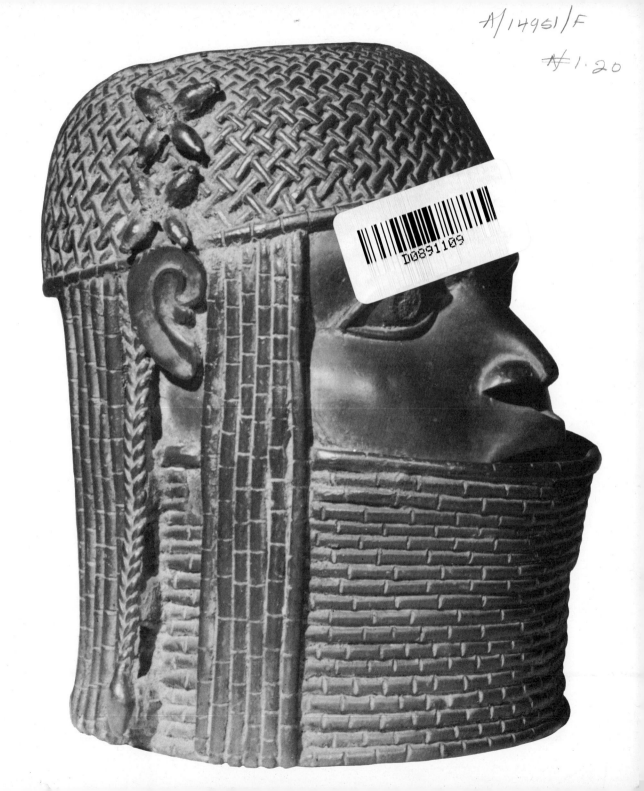

Oba Akenzua II seated in front of the altar
of his father, Eweka II, at the annual
ceremony of propitiating his spirit.
Photograph: R. E. Bradbury.

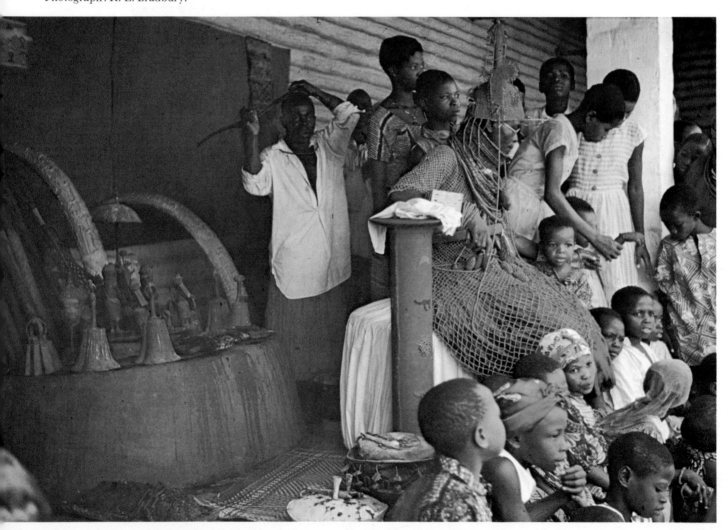

Published by the Trustees of the British Museum
London 1970

Divine kingship in Africa

William Fagg

SBN 7141 1511 8

© The Trustees of the British Museum
Printed in Great Britain by
Shenval Press

The Department of Ethnography
is at 6 Burlington Gardens
London WIX 2EX

List of plates

Male bronze head of the early phase of the Middle Period (see Plate 7, left)
Oba Akenzua II before his father's altar *frontispiece*

		page 7
1	Bronze plaque showing a gate of the Palace at Benin	
2	Bronze plaque showing the Oba of Benin in divine aspect	11
3	Two bronze queen-mother heads of the Early Period	13
4	Male bronze head of unique form, of the Early Period	13
5	Pair of ivory leopards, probably of the nineteenth century	14
6	Terra-cotta head similar to bronze heads of the Early Period	15
7	Two male bronze heads of the Middle Period	17
8	Bronze figures of the Middle and Late Periods	17
9	Bronze equestrian figures of the Middle and Late Periods	17
10	Three male bronze heads of the Late Period	18
11	The ancestor altars of the last three Obas of Benin	19
12	Bronze Altar of the Hand of an eighteenth-century Oba	21
13	Bronze cock for the Obas' mothers, Late Period	21
14	Bronze leopard aquamanile, Middle Period	22
15	The Oba with his ivories at the *Emobo* ceremony	25
16	Ivory double bell and striker, probably of the Early Period	26
17	Ivory mask of the Early Period	26
18	Ivory double armlet, probably of the Early Period	27
19	Ivory armlet with Portuguese heads, Early or Middle Period	27
20	Bronze head for the spirit cult, Late Period	30
21	Two bronze headdress masks, Late Period	31
22	The *Ododoa* masquerade about 1959	32
23	Three bronze figures of Portuguese soldiers, Late (left) and Middle Periods	33
24	Chief Osuma in full dress	35
25	Bronze plaque by the Master of the Circled Cross	37
26	A chief salutes the Oba with his *eben*	38
27	Bronze plaque by the Battle Master	40
28	The seated bronze figure of Tada on the banks of the Niger	44
29	Ivory salt in the Bini-Portuguese style	46
30	The Chairwoman of a ladies' club at Benin	47
31	Crouching bronze figure of a warrior, Lower Niger Bronze Industry	48
32	Wooden doors from Ikere-Ekiti, by Olowe of Ise, Yoruba	50
33	Bronze ewer of Richard II and Ashanti *kuduo*	51
34	Soapstone figure of a woman from Zimbabwe	52
35	A royal palm-wine cup from the Bakuba, Congo	52
36	Carved palace door from the Bamileke, Cameroon	54

Preface and dedication

When this exhibition, consisting principally of the antiquities of Benin, was being planned during 1969, there was every intention of relying heavily upon the vast store of learning accumulated over the past decade and a half by Dr Robert Elwyn Bradbury, of Birmingham University, who had made this richest of African cultures his own to an extraordinary degree. He would have collaborated wholeheartedly in the enterprise, which would have been greatly enriched by his contribution, combining in a unique way the insights of his very broad conception of social anthropology with those of material culture. But at Christmastide 1969 he died suddenly of pneumonia at the age of 40, leaving very little of his work in published or publishable form. Without a doubt he could have corrected many nuances of interpretation and some errors of fact in this exhibition and this booklet. Yet even so they reflect more or less subtly, though imperfectly, the pervading influence which his work has had on Benin studies. Study of his masterly paper on the *ikegobo* or cult of the hand (in *Man*, Vol LXI, 1961, article 165, pp 129–38) shows that he had made the first great breakthrough .in the close association of social anthropology and material culture for the solution of a common problem without the slightest trace of doctrinaire views on either side. It seems fitting to dedicate this small volume to his memory.

In the preparation of the data for the exhibition, the first to show at one time the British Museum's entire Benin collection – the largest in existence – and certainly the first to attempt a reconstruction of a part of the palace in which to show them, I have had much help over several months from Marilyn Hammersley of Northwestern University, Evanston, Illinois, Doreen Nteta of the National Museum of Botswana, and especially John Picton, Assistant Keeper in the Department. I am particularly grateful to Mrs Rosalind Bradbury for making her late husband's very large collection of photographs freely available to me for use in the exhibition and this booklet.

WILLIAM FAGG
Keeper of Ethnography

Plate 1
Bronze plaque representing a gate of the Oba's Palace with shingled roof and, on the tower, a large figure of a python (formerly surmounted by a bird), with attendants. 22½in (45cm).

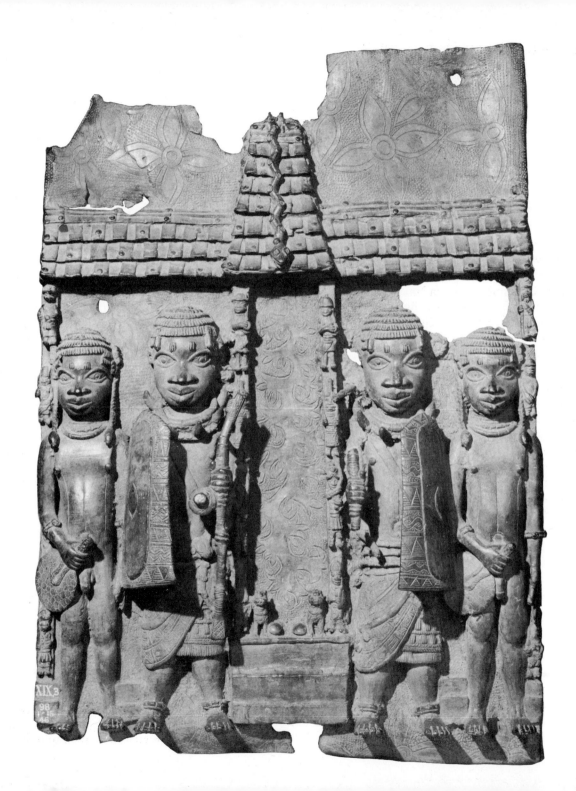

7

Benin – which is chosen to represent the idea of African kingship not because it is by any means the most typical, but because the Benin collections are very large and form a unique kind of constellation about the concept of the divinity of the king, which can thus be illustrated in a great variety of ways – is of all the great mediaeval empires of Africa the only one which existed and held sway within the dense and normally inhibiting environment of the great rain forest. The people call themselves and their city Edo; but the Portuguese introduced the city to Europe as Benin (Benim), it is not known precisely on what authority. The Edo (or Bini) are one of the several Edo-speaking tribes, most of which were at one time under the suzerainty of Benin. According to Bradbury's *Survey* (1957), estimated numbers were then: the Edo proper or Bini, 203,000, the Ishan to the north-east of Benin, 185,000; four branches of the Northern Edo, the Ivbiosakon, 53,000, the Etsako, 88,000, the North-West Edo, 46,000, and the Ineme, 6,000; and the Urhobo and Isoko of the Niger Delta to the south of Benin, 345,000. The Bini are, even now, an amazingly small tribe to have conquered and managed so great an empire – stretching at some times to Lagos (whose vernacular name, Eko, commemorates its origin as a 'war camp' of Benin) in the west and beyond the Niger to the east. Certainly the great warrior kings of the fifteenth and sixteenth centuries played a great part in their military ascendancy; and it may well be that if the form of kingship imported from the Yoruba city of Ife at some time between the eleventh and the fourteenth centuries had not suffered a sea change in adapting itself to the alien village structure of the Edo-speaking peoples, becoming thereby much more tolerant of absolutism, then such sustained and far-reaching victories would never have been possible. Indeed, in this as in some other respects, the Yoruba city-states were like those of ancient Greece, exciting our admiration for the sensibility and beauty of their art and culture, but quite unable to combine for war; while Benin was equally comparable with Rome under the Emperors, its kings surrounded by supporters and sycophants, rather than by an opposition, their armies irresistible under war chiefs who did not become hereditary until late in the eighteenth century, their art somewhat brutal and pedestrian, once the humanising influence of Ife had worn off, early in the Middle Period.

In 1892, Capt Gallwey (later Sir Henry Galway) had gone up to Benin (previously something of a 'forbidden city' to the white man, like Timbuktu) to negotiate a treaty on behalf of the Queen with Oba Ovonramwen, among the intentions of which were that he should put an end to the practice of human sacrifice, and allow reciprocal trade (of which the king had a monopoly). Five years later, when it was clear that neither intention was being observed, Consul Phillips, a brave but somewhat foolhardy man, led an unarmed party of nine white men and about 280 Negro porters and attendants on a journey to remonstrate with the king, although he had sent word that he was 'making father' (celebrating the annual festival in memory of his father, Oba Adolo, and other ancestors, of which human sacrifice on a considerable scale was an essential part), and could not receive him. A few miles inland from the

river port of Ughoton, on 4 January, the party was ambushed and massacred by a group of diehard chiefs, led by Chief Olugbushe, who, as it later turned out, were acting without the Oba's knowledge. Two British officers managed to make their way back to friendly territory and raise the alarm. Meanwhile at Benin there were scenes of indescribable panic when news of the massacre became known: to avert the expected punitive expedition, the Oba sought to propitiate the gods with far greater numbers of human sacrifices than ever before. The Expedition was mounted with commendable speed, from Simonstown in South Africa and from home waters, and in spite of some determined opposition, captured Benin on 17 March 1897. There are many eyewitness accounts of the horrifying spectacle of death which met them, and they would have assumed that Benin was normally as bloody as they found it.

The Oba had fled (but later gave himself up and lived the last seventeen years of his life in exile at Calabar), and the British quickly established an orderly administration. Within a few days, a disastrous fire swept through part of the city, including part of the British occupied area, and this seems to have burned some of the elephant tusks in the palace. All the bronzes were already in the palace (because the Oba permitted no one else to have them), and were now concentrated in one of the great courtyards. Most of these had a clear association with the cults of human sacrifice, and it would not have been at all surprising that the Expedition decided to remove them all, even if the taking of booty had not still been sanctioned by international law and practice in those days. Some of the officers carried out valuable research in the oral traditions of Benin, and recorded the story of the origin of Benin bronze-casting at Ife in Yorubaland some thirteen years before it became known that there was any art at Ife. These traditions are given at length in the book *Antiquities from the City of Benin* by Sir Hercules Read and O. M. Dalton, published by the British Museum in 1899.

Divine kingship as represented at Benin

Among the stolidly matter-of-fact representations on the bronze plaques, there are a small number in which the supernatural finds a place. They represent an Oba-like figure who has mudfish instead of legs – and, in one case (see plate 2), the hardly less divine attribute of being shown in the act of swinging two leopards. This figure may represent a god in semi-human aspect as an Oba of Benin, or an Oba in divine aspect, or an Oba in normal aspect but with somewhat fanciful reference to a pathological condition. The third explanation, preferred at Benin today, is the least likely and is probably a modern rationalisation: namely that the fourteenth-century Oba Ohen suffered paralysis of both legs during his reign, and gave out that he had 'become Olokun' (the sea god), his legs turning into mudfish, Olokun's symbol. It is perhaps safest to assume that it is a 'heraldic' representation of an Oba – perhaps any Oba – in divine aspect. This would best account for the swinging leopards.

A shield-shaped plaque with a similar device is a fine example of the Late Period, probably to be assigned to the reign of Eresonyen (c 1750), whereas the rectangular plaques are all of the Middle Period (c 1550–1650). The sheet brass example is of the nineteenth century.

The royal leopards

The Oba of Benin seems to have carried much further the common practice in Africa of treating the leopard as the main symbol of chieftainship, because it embodies qualities such as courage, strength, ferocity and cunning which are considered appropriate for chiefs. At Benin, the Oba appears to have maintained a menagerie, where captive leopards would be fed on goats and other animals. To catch the leopards alive, hunters wore special armour which seems to have been made from the skin of the pangolin or scaly anteater.

The leopard is a constantly recurring symbol in Benin iconography; examples are shown of waist masks (worn in threes from the belt) and of hip masks (worn by chiefs on the left hip over the crossing of the kilt).

An extraordinary piece of joinery in ivory is a pair of leopards each made from five separate tusks, with spots formed from copper discs tapped into undercut depressions in the ivory, and with pieces of mirror for eyes. These fine leopards (see plate 5) appear to be copies, made perhaps early in the nineteenth century, to replace earlier examples, the head of one of which survives in the Museum für Völkerkunde at Vienna. They are lent by HM The Queen, having first been placed on loan in the Department by King George V.

Plate 2
Bronze plaque showing the Oba of Benin in divine aspect. 15½in (40cm).

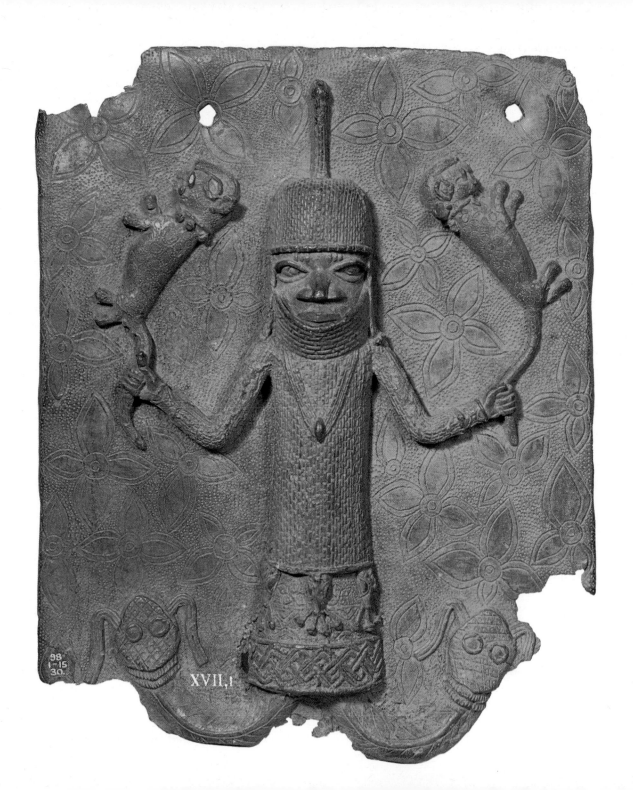

XVII,1

II

Eguae: the Oba's palace

The reconstruction of a court of the Palace essayed in this exhibition is a notional one and is intended to give only an impression of the Palace of some four centuries ago, about which the evidence is not sufficient for a more accurate reconstruction. There are reports by Portuguese and other travellers, somewhat free contemporary representations in engravings, such as that published by Olfert Dapper in 1668 and often reproduced, and also reproductions by the Bini themselves of parts of the Palace, in two of the rectangular plaques of which one is illustrated in Plate 1, and in a long bronze box in the Berlin Museum, seen here in a photograph in the exhibition. These Bini representations always show the roof as shingled, a practice probably introduced from Europe. For the purpose of this exhibition some research has been devoted to the probable method of shingling. The wood concerned is very probably one known at Benin as *umokhan* (and botanically as *Pycnanthus kombo*), nowadays imported on a small scale to Great Britain as *abura,* and still used for making shingles in the coastal areas of Cameroon. This wood was split to make shingles of the probable shape and size, one of which is shown. A partial reconstruction of the roof was then cast in fibreglass from a small section made up in the original wood.

On the gate towers were mounted great bronze pythons said to have been 40 feet in length (and which do not recur elsewhere in Benin iconography except in the spirit cult). They were presumably a symbol of the Oba's power and may be connected with important python cults to the south-east in the Niger delta.

The objects displayed in the exhibition would in fact have been distributed through many courts of the vast, rambling palace. In 1897, there were thirteen very large courts each devoted to the service of the ancestor cult of one of the past Obas. In all probability the Palace took up nearly half the area of Benin city and there would have been hundreds of courts with impluvia more or less on the Roman pattern.

The only portable parts of the Palace, four keys, are also shown.

The Oba's ancestors: the Early Period

In the case devoted to the Early Period are seen two male heads in bronze; one female head, believed to represent a queen-mother; a terra-cotta head of the same form as the male bronze heads (but representing ancestors of chiefs of the bronze-workers, not of the Oba); two miniature bronze heads which may date from the very end of the Early Period; a miniature terra-cotta head (also from the bronze-workers' altars) for comparison; and a pendant mask in the Early style.

The Early Period terminates with the beginning of the Middle Period, which is defined as the period of manufacture of the rectangular bronze plaques which adorn the pillars in this courtyard, beginning about 1550. It is, however, uncertain when the Early Period began or even whether it was before or after the arrival of the Portuguese at Benin in 1486 or thereabouts. According to legend, bronze-casting was learnt from Ife in Yorubaland in the reign of Oba Oguola, who may have lived during the thirteenth or fourteenth century. None of the known pieces in the early style shows any evidence of contact with the Europeans, although oral history says that the elevation of the mother of the Oba to an important place in the Kingdom was first instituted by Oba Esigye early in the sixteenth century, after the Portuguese arrival; it is improbable that a special cult with bronze heads would have been set up for the Queen-Mother until this formal step had been taken.

The bronze head of a queen-mother (Plate 3) is of the earliest type. Two other queen-mother heads, and possibly three, by the hand of this great master are known, at Lagos, at Liverpool, and in Berlin. The naturalism of the modelling of the head is close in many respects to that of the Yoruba of ancient Ife, seen in a display nearby. However, the head has at the same time the stylized aspect of a falling drop of water. It is likely to have been made about the second quarter of the sixteenth century.

Next is a fine example of a naturalistic Oba's head in bronze of the earlier type. There is much greater variety among the twenty or so heads of this type than in the later periods when the heads were more stereotyped. It should be noticed how the coral bead orna-

Plate 3
Two queen-mother heads by the same
artist, in the British Museum (left) and the
Nigerian Museum, Lagos. They are of the
Early Period. 15½ and 20in (39 and 51cm).

Plate 4
Male bronze head of the Early Period, of
unique form. 7¾in (20cm).

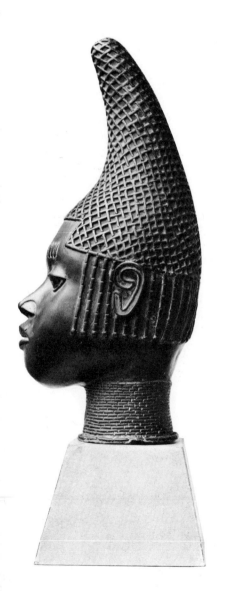

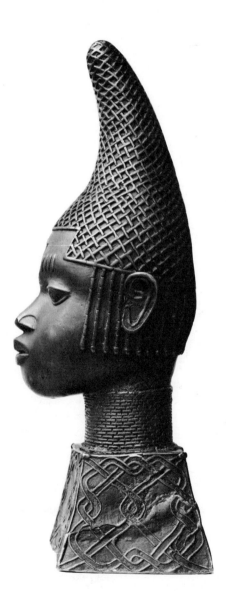

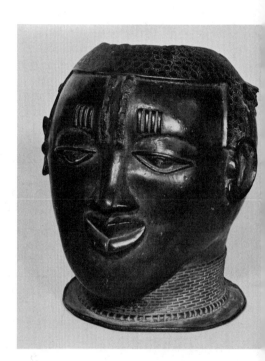

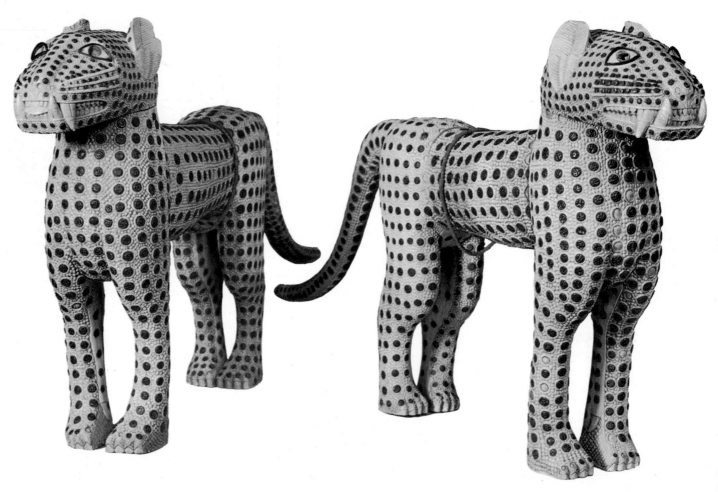

Plate 6
Terra-cotta head very similar in style to bronze heads of the Early Period. 8¼in (21cm).

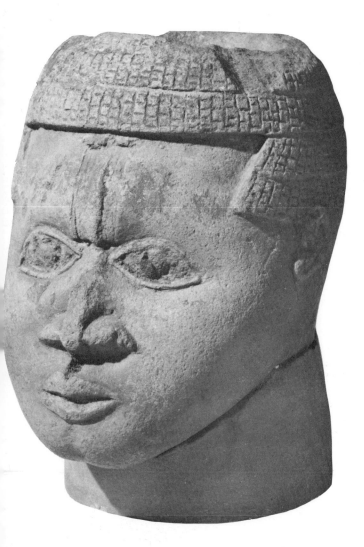

ment of the neck is discreetly subordinated to the naturalistic representation of the face, whereas in the Middle Period the beads begin to dominate the face.

A unique example of an early head of an Oba (Plate 4) appears to show some kind of pathological condition such as acromegaly. The researches of the late Dr R. E. Bradbury established that in the later periods the bronze heads were generalised representations of an Oba and not portraits of a particular Oba. It is probable that this was so also in the Early Period, and in this case it is possible that the peculiarities of this head represent not a realistic portrayal of a particular Oba's condition, but the artist's preferred, and highly original, method of showing the human head. This piece is also unique among Early Period heads in having a flange around the base.

For comparison with the royal bronze heads is a terra-cotta head of a chief of the bronze-casters (Plate 6) apparently of the Early Period, since it closely follows the style and ornamentation of Obas' heads of this period. In the sixteenth century chiefs other than the Oba were allowed only to put animal representations on their fathers' altars, but it seems likely that the chiefs of the bronze-workers' guild (*Iguneromwon*) were from the beginning given the privilege of employing heads like those of the Oba, but in terra-cotta instead of bronze.

Three miniature heads in bronze and terra-cotta are probably all from the Early Period. The largest appears, from the scarification marks above the eyes, to date from the very end of the Early Period, or possibly from the beginning of the Middle Period. The purpose of these miniature heads is not known, but the terra-cotta is presumably from one of the bronze-casters' ancestor altars. A bronze pectoral or waist mask is in a similar style (though smaller) to the famous mask of the Ata of Idah, an Early Period Benin mask, about 12 inches (30cm) high, which may date to the time of Oba Esigye, who conquered Idah about 1515.

Aru-Erha: a royal ancestor altar of the Middle Period

A partial reconstruction has been made of one of the altars at which the Oba made sacrifice to the spirits of deceased Obas (his 'fathers') in the period from about 1550 to 1650. Each of the more important Obas had a large compound devoted to his memory.

In the Early Period, the heads (for examples see a nearby case) were extremely thin – about a millimetre thick over most of the surface – because they were still made from scarce native African copper alloys. The beginning of the Middle Period is marked by the arrival of plentiful supplies of Portuguese bronze, and this greatly influenced the style both of the bronze heads which were placed on the ancestor altars and of other bronzes which were now made in greater profusion, and which especially included the plaques, made only during the Middle Period to adorn pillars in the Palace.

Of the three bronze heads on this altar the central (smaller) one (Plate 7, left) appears to be the earliest, perhaps made very soon after 1550, while the other two (Plate 7, right), which are slightly larger, are typical of the majority of the heads made in this period. These heads appear (unlike the earlier ones) to have been designed to sustain the weight of heavy tusks such as are placed upon these examples (although all the tusks seen here must in fact have been made quite late in the Late Period, since there are believed to be no such tusks extant from the Middle Period).

Also on this altar are two figures representing the Oba's hornblowers or trumpeters, which are clearly in the same style as the heads; a figure of a messenger bearing a cross (Plate 8, left); and a figure of a mounted warrior (on a horse or a mule) (Plate 9, left) which appears to represent an emissary from one of the northern Moslem rulers.

Plate 7
Two male bronze heads of the early (left) and later phases of the Middle Period. $9\frac{1}{4}$ and $11\frac{3}{4}$in (24 and 30cm).

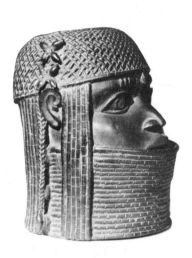
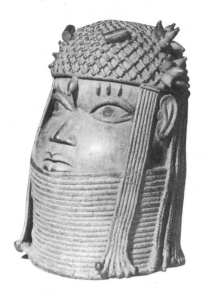

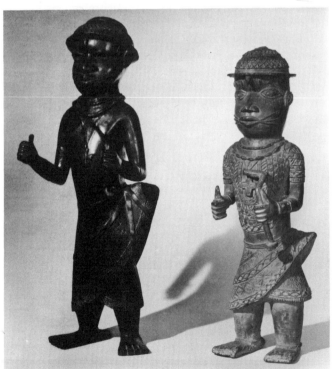
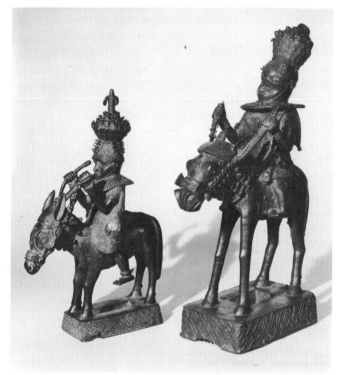

Plate 8
Bronze figures of the Middle (left) and
Late Periods, described as messengers
from Ife. 25¼ and 22½in (64 and 57cm).

Plate 9
Bronze equestrian figures of the Middle
(left) and Late Periods. 19 and 23½in
(48 and 60cm).

Aru-Erha: a royal ancestor altar of the Late Period

In the heads of the Late Period, the humanistic naturalism inherited by the early Benin master bronzefounders from Ife has been finally snuffed out, while the anti-humanistic emphasis on beadwork ornaments, already dominating the face in the Middle Period (in what may be called a 'baroque' phase), now breaks through all restraints and eventually attains levels of absurdity not otherwise found in Africa before the rise of the modern export trade. Immense proliferation of ornament and other rococo-like features abound increasingly, especially in the nineteenth century.

The bronze heads (Plate 10) – which are not of course to be regarded as portraits of individual Obas, but as generalised representations of which six or eight identical examples were placed upon each Oba's altar – continued to increase in size throughout the Late Period, lasting from the late seventeenth century until the fall of Benin to the British in 1897. Gradually more appendages and accretions were added to them, beginning with a flange around the base bearing various symbols of kingship, and ending with the addition (according to tradition, in the reign of Oba

Osemwenede, 1816–48) of elaborate wing pieces on the crown together with large carnelian beads wired to stand out in front of the face.

Quite early in the Late Period, the necks, encased in tubular beadwork collars, lengthened to an unnatural extent, culminating in the bathos and fatuity of the head which is evidently one of those made for the original altar of Oba Adolo, presumably erected by his successor Ovonramwen the year after his death in 1888, and which is seen on the extreme right below the altar.

There is one short period about the middle of the eighteenth century, namely the reign of Oba Eresonyen, which is regarded in Benin history as a time of renascence of the bronze-casting industry, and many of the best works of the Late Period are conjecturally attributed to his time, although excellent bronzecasters occasionally appeared at other times. In general the flamboyance of the Late Period corresponds to a loss of real power by the Obas (perhaps slightly arrested in Eresonyen's time), and may be regarded as a kind of frenzied over-compensation.

Of the other round sculptures on this altar, the most important is the mounted warrior (perhaps riding a mule, since Benin is in the tsetse belt); its rude vigour

Plate 10
Three male bronze heads of various phases of the Late Period. That on the right is thought to have been made after the death of Oba Adolo who died in 1888. 12, 20½ and 21¼in (30, 52 and 54cm).

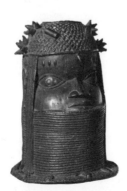
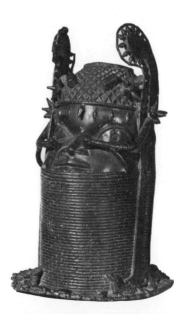
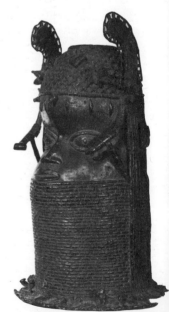

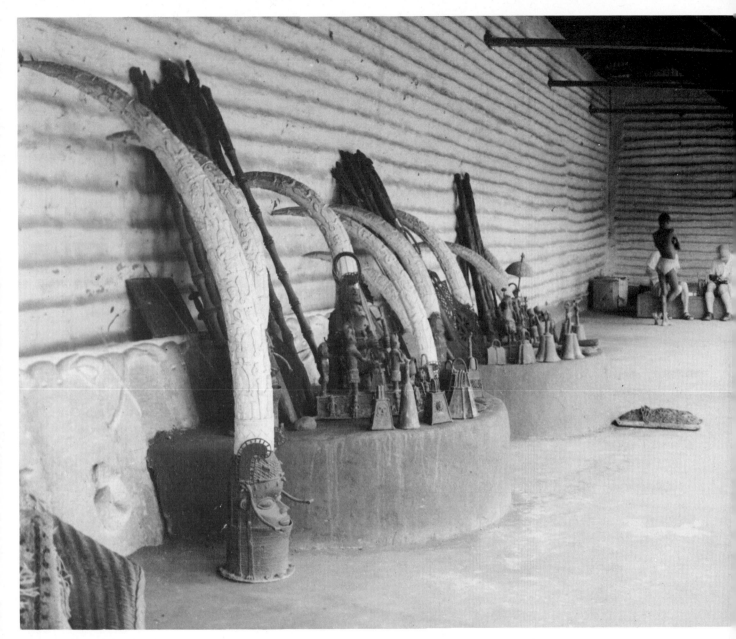

Plate 11
The present ancestor altars of the Oba of
Benin: centre, that of Eweka II, his father
(*ob* 1933); left, that of Oba Ovonramwen
(*ob* 1914); right, that of Oba Adolo
(*ob* 1888).
Photograph: W. B. Fagg, 1958.

(Plate 9) may well place it higher as sculpture than the much more finely decorated example on the Middle Period altar to the left.

A photograph taken in 1958 (Plate 11) represents the three altars maintained by the present Oba in honour of his father, Eweka II, who died in 1933 (centre), his grandfather, Ovonramwen, who died in exile in 1914 (left), and his great-grandfather, Adolo, who died in 1888 (right). A simpler altar, without bronzes, is devoted to all previous Obas. Up to 1897, there were still thirteen such great compounds devoted to the most important of the old Obas.

The Oba's Ikegobo or altar of the hand

A bronze altar piece (Plate 12) for the cult of the king's hand was probably made in the second half of the eighteenth century. The hand, in a ritual context, signifies a man's power to do things, *ie* his own ability to achieve success in material and practical things. Its worship is particularly characteristic of warriors, and is also practised by other wealthy and high-ranking people.

The other part of the human body which is an object of cult is the head, which signifies good fortune. Unlike the cult of the hand, however, the head has no altar dedicated to it, as sacrifices are applied directly to one's head. All Edo men will sacrifice to their head from time to time.

In the case of the king, the cults of his hand and in particular of his head have a wider significance involving the achievements and the good fortune of the entire Edo kingdom. Indeed, the annual sacrifice to the king's head can be regarded as the central rite of his divine kingship.

Aru-Iya: the altar of the Oba's mothers

Two bronze female heads, a cock and an altar piece are for the cult of the king's mothers (*ie* his own mother and those of the preceding kings, from whom he descends in the direct male line). These pieces are all of the Late Period, the finest and earliest being the cock (Plate 13), which may date from the reign of Oba Eresonyen (about 1750), while the other three were probably made at various dates in the nineteenth century. The two heads of queen-mothers may be compared with the beautiful queen-mother head from the Early Period exhibited in the courtyard; probably none of these is intended as a portrait so much as a generalised representation of the office (as with the male heads on the altars of the king's fathers, *aru-erha*).

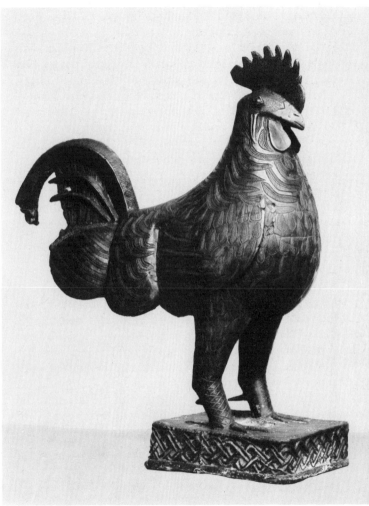

Plate 13
Bronze cock from the altars of the Oba's
'mothers'; Late Period. 20in (51cm).

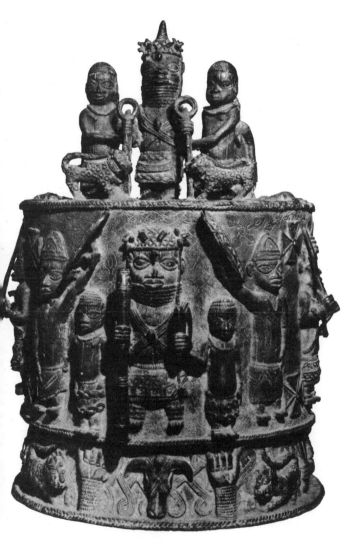

Plate 12
Bronze Altar of the Hand (*ikegobo*) of an
Oba of the eighteenth century. 18in
(46cm).

The royal ablutions

Before the Oba emerges from the Palace at the beginning of each of the major ceremonies of divine kingship at Benin, his hands are ritually washed by an official whose task this is. A photograph in the exhibition shows this official on his way in to the Palace in 1958, carrying a dish and aquamanile or ewer in the form of, in this case, a leopard.

Of all the pieces exhibited here, the leopard with spots formed by circled crosses is probably the earliest and may even be by the Master of the Circled Cross, who was probably the first to make rectangular plaques for the royal pillars, perhaps about 1550. The other leopard (Plate 14) and the ram aquamanile are also of the Middle Period (about 1550–1650). The more ornate upright vessel bearing a representation of a baboon, on the other hand, belongs to the Late Period and probably dates from the latter part of the eighteenth century; it is one of four or five known examples of the type, all more or less contemporary in style, so it may represent a temporary change in fashion.

Aquamaniles (or aquamanilia) in the form of animals or horsemen were characteristic of German and Frankish culture in the Middle Ages, and appear to have gone out of use in Europe by the end of the fourteenth century, nearly a century before the discovery of Benin. It is unknown whether the idea spread across the Sahara in mediaeval times or whether the Portuguese imported specimens in the late fifteenth century which were already antiques in Europe. That there was a connection is evident from the fact that the method of filling, through a hole with a hinged lid in the head of the animal, and of pouring, through the nostrils, is the same.

Plate 14
Bronze aquamanile in the form of a leopard, Middle Period. 12¼in (31cm).

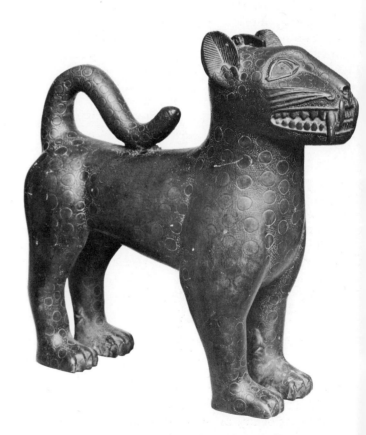

The king's coral-bead treasure

The Oba's coral-bead regalia, of which he has always had a monopoly at Benin and from which he makes sparing gifts to chiefs at their installations, seem to have had a very special significance, for they were the subject of an annual ceremony of their own, in which a man was sacrificed over them.

The people of Benin say that this coral grows in the creeks of the Niger Delta, and, more poetically, that the great Oba Esigye (about 1500) went down to the shore and wrestled with Olokun, god of the sea (and of wealth), and won his beads from him. But in fact West Africa has no coral and the Benin coral is of the Balearic type from the western Mediterranean. It must have been imported by the Portuguese, and if Esigye did go down to the Delta, the 'wrestling' must have been hard trading.

The few samples of the Oba's bead clothing are but a small proportion of the extremely heavy weight of beads worn by him at most of the important ceremonies. The cap, tunic and apron are of the simplest form; the 'flywhisk' – weighing $5\frac{1}{2}$lb (2·5kg) – is an example of the exaggerations to which the Oba submits.

An elbow-rest used by the Oba at all ceremonies (probably dating either from the eighteen-nineties or from the restoration of the monarchy after 1914) is of similar size and shape to that which supports his right arm in the Frontispiece, and is there covered in beads. Though a simple cylinder of sheet brass, it reproduces the form of the ritual boxes (ekpokin), made of interlocking cylinders of bark or leather, which are one of the attributes of divine kingship in most parts of southern and central Nigeria. The Oba's throne itself is one of these, though, being concealed by cloth (see the frontispiece), it is never seen by the public.

The eben and the ada

The two ceremonial swords, eben, left, and ada, right, are of types used as sanctions of chieftainship deriving from the Oba. They are also used as symbols of his own kingship, and the ada at least was almost certainly the Oba's own. All chiefs (of whom there are several hundred at Benin) are entitled to have the eben carried before them and to use it in an elaborate dance of homage to the Oba (which may also include propitiation of the earth spirits). At the climax of ceremonies of homage, the Oba comes down from the dais and performs the homage dance (including the throwing of the eben high in the air with a spinning motion) before his own throne, which, though covered in cloth, is a cylindrical bark box-throne. The right to have the ada carried in procession before one is apparently restricted to the much smaller number of hereditary chiefs of the royal lineage. The ada probably has some reference to the power of life and death, whereas the eben may be derived originally from a large fan.

The bird of disaster

Three examples, probably of the eighteenth or nineteenth century, are on show of the 'bird of disaster' (ahianmworo), which symbolized the superiority of the Oba to the fate which rules the life of ordinary men. When the warrior Oba Esigye went forth to war against the Ata of Idah in about 1515, this bird of ill omen (sometimes identified with the ibis) made such deprecatory noises overhead that the soothsayers warned the Oba to call off the expedition, since he would certainly be defeated. But Esigye refused to turn back and ordered that the bird should be killed. He went on to win a great victory against the Ata, and decreed that figures of the bird should be cast in bronze and beaten with metal rods in his presence as a part of court ceremonial in commemoration of the event.

The king's ivory treasure

The most valued of the Oba's belongings appear to have been the ivory ornaments which he wore on certain ceremonial occasions – notably that of dispersing the friendly spirits assembled for the annual festival of the renewal of the powers of the divine king (Plate 15); many of them had been kept intact, or almost so, for three and a half centuries. They were found by the Expedition in 1897 in a large chest in the Oba's bedchamber – almost certainly the one exhibited in the courtyard – and included five or six belt masks, four or five bells, many of the finely carved armlets, and other ornaments.

When an elephant was killed in the Benin kingdom, one tusk had to be presented to the Oba – like the (recently terminated) 'divine right' of British kings to sturgeon caught in British waters; the other had to be offered to him for purchase, but most probably he would rarely have had occasion to avail himself of this right. Thus there was no embargo – as there was in the case of bronze – on the use of ivory by the rest of the population and in fact the *Igbesamwan,* or guild of carvers in ivory and wood, worked both for the Oba and for other chiefs throughout the kingdom. Perhaps for this reason, we find little sign of any falling-off in the quality of the best ivory-carving between the sixteenth century and the end of the nineteenth, whereas bronze-casting, tied inextricably to the fortune of the kings,

reflects, in a progressive degeneration, the waning power and waxing pomp of the monarchy.

The mask (Plate 17), probably the finest in existence, is of the type worn, probably in threes, on the Oba's belt (as is seen on several of the bronze plaques), and has the two pieces of iron inlay above the eyes which are a mark of the Early Period (up to about 1550). Its tiara of heads of Portuguese suggests the prestige accruing to the Oba from their friendship.

The double bell (Plate 16) seems to be of the same age, and equal mastery of design. The Oba is seen on each side of the bell, once in human aspect, his hands ceremonially supported by two chiefs, and once in divine aspect with mudfish for legs and swinging a pair of crocodiles. The present Oba still uses a double bell of plain ivory at the annual ceremony of the dismissal of the spirits, as is seen in the photograph (Plate 15).

The finest pair of armlets (Plate 18) are a remarkable *tour de main,* each in the form of two interlocking cylinders carved from a single block of ivory, and are again a masterpiece of sixteenth-century design. Most of the other armlets (Plates 18 and 19) are of the same age, or later copies which retain the old mastery.

A carving in the form of a leopard passant, of uncertain age, may be a forearm ornament for use in the same ceremonies. The lid of an annular box, probably for valuable beads, is a fine work in another style, probably of the seventeenth or eighteenth century.

Plate 15
The present Oba wearing many ivories and striking an ivory double bell at the ceremony of dismissing the friendly spirits.
Photograph: W. B. Fagg, 1958.

24

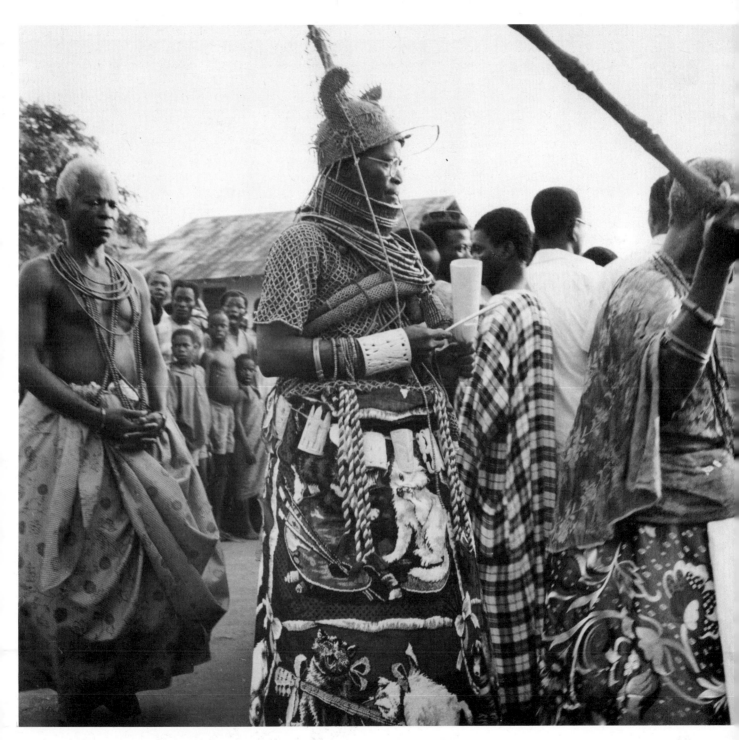

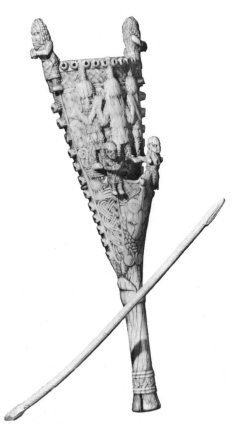

Plate 16
Ivory double bell and striker, probably of
the Early Period. 14¼in (36cm); striker:
11in (28cm).

Plate 17
Ivory pectoral or waist mask of the early
sixteenth century, with a tiara of
Portuguese heads. 9¾in (25cm).

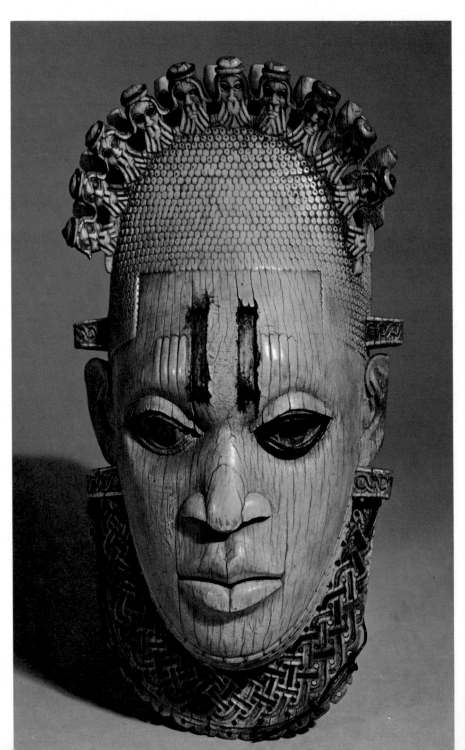

Plate 18
Ivory double armlet, inlaid with bronze:
probably of the Early Period. The forms
representing two elephant skulls back to
back are carved on the inner cylinder,
those of the Oba in divine aspect on the
outer. $5\frac{1}{4}$in (13cm).

Plate 19
Ivory armlet with a 'gothic' design of
Portuguese heads spaced by *eben* swords;
Early or Middle Period. 5in (13cm).

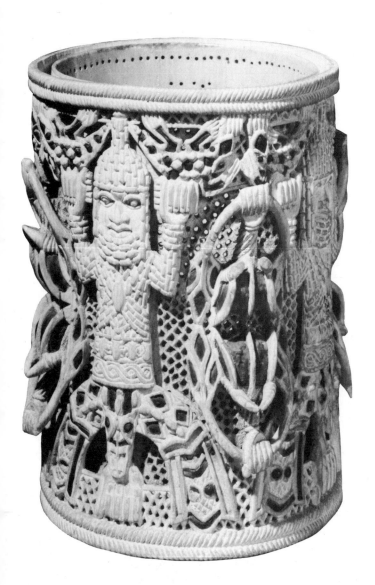

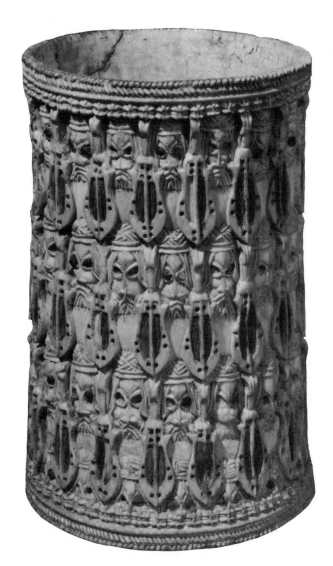

Court dress and adornment

A standard component of court dress are the bronze ornaments given by the Oba to chiefs and worn by them over the knots of their ceremonial kilts or skirts, as in the accompanying photograph by the late Dr R. E. Bradbury of Chief Osuma in his court dress (Plate 24), or as belt masks, to be hung in threes from the belt.

A tunic imitating the form of a leopard skin with the features of the face visible on the chest is the only example of the kind in the collection. The red cloth, similar to baize, is imported. This piece no doubt dates from immediately before the Expedition of 1897.

The two bronze wands, probably of the eighteenth or nineteenth century, which are seen in use on one of the rectangular bronze plaques in which three men carry similar objects with the blades upwards, are quite common, but of uncertain use.

In addition, there is an assortment of combs, hair pins, pendants, rings, beads, bracelets and cuff armlets (Plates 24, 26 and 30).

The king's music

Six of the bronze plaques showing musical subjects are here shown, as follows:

(i) Two of the royal drummers with an assistant. These drums might be used in the ceremony of dismissing the spirits (*emobo*).

(ii) A musician playing upon two slit drums (more properly described as bells). By his right shoulder is a box in which is a coiled and spitted mudfish. Above this is another box shaped like a sugar loaf and at the left three objects which may be small cannon. This plaque is the only evidence for the use of such instruments in ancient Benin, though they are still found among the surrounding tribes.

(iii) Two chiefs, one of whom carries a double bell, probably of ivory (though bronze copies of these bells are known). An actual example of these bells, with an ivory striker, is displayed with the Oba's ivory treasure in the courtyard.

(iv) A man playing a pluriarc or, more loosely, a kind of harp.

(v) A man playing a tension drum, with membranes at each end, the pitch of which can be varied by pressure with the elbow on the strings so as to imitate the varying tones of speech. It is popularly known as a 'talking drum'.

(vi) Two men playing iron double bells with a third who is playing a calabash rattle.

Other plaques showing musicians will be found on the pillars surrounding the impluvium. Miscellaneous further evidence and actual instruments are here grouped together:

(i) An ivory trumpet similar to those played by the Oba's hornblowers (Benin trumpets are, exceptionally, blown on the outside of the curve).

(ii) Two crotals on long handles.

(iii) Two rattles or bells.

(iv) A vertically blown flute or whistle.

(v) A linguaphone or 'thumb piano'.

(vi) A bronze waist ornament depicting a player on the calabash rattle.

(vii) A typical Benin drum with two membranes.

(viii) Two single-membrane drums.

(ix) A musical bow, played by plucking while the mouth is held close to the strings.

Further evidence is shown in photographs in the exhibition, as follows:

(i) The Oba's hornblowers greeting him with blasts on their ivory trumpets.

(ii) The Oba's drummers drumming up a crowd for a ceremony on static single-membrane drums.

(iii) Drummers carrying very long tension drums.

(iv) Drummers with the special drums used at the ceremony of dismissing spirits at the end of the main festival of the divine kingship ritual.

The spirit cult

The spirit or 'medicine' cult has been overshadowed at Benin by the spectacular cult of the Oba's ancestors, but in the view of the late Dr R. E. Bradbury it lies very close to the centre of the divine kingship at Benin. Much of the cult was carried on in the seclusion of the Palace and not in the public view. The art associated with it was, therefore, not subject to the same exaggerations and fantastications which accrued around the ancestor cult in inverse proportion to the real power of the monarchy.

The spirit cult is based on a belief that the well-being of the people depends directly upon the Oba's life force or spiritual energy and this is a special form of the very widespread belief among African tribes in 'force' as the nature of being.

At Benin objects connected with the spirit cult are generally grotesque in character, that is they have reptiles, snakes, and other animals represented upon them. Of those gathered here some are known to be for a spirit cult, some others are conjecturally attributed to it. The large iron and bronze staffs known as *osun nigiogio* (after Osun, the spirit of medicine) are the most characteristic features of the cult. The human head (Plate 20) with snakes issuing from the nostrils and surmounted by birds is also important and may be compared with the ancestor heads of the Late Period, to which it belongs but whose decadence it does not seem to share.

The *Ododoa* masquerade, in which grotesque bronze headdress masks like the two shown (Plate 21) are used, is an important part of the *Agwe* ceremony in which sacrifices are made of new yams at a number of shrines within the Palace (Plate 22), and is undoubtedly to be connected with the medicine or spirit cult.

In the action at the landing at Ughoton in 1897, the British Expedition met a procession of masked figures mingling with the resisting soldiers. These were the devotees of Igbile and their masks were captured by the invaders. Three of them are shown in the exhibition. Copies made later from memory are still in use there. The cult is evidently of Ijo origin, to judge by the style, but came to the Bini by way of the Ilaje Yoruba.

Plate 20
Bronze grotesque head for the spirit cult;
Late Period. 10¾in (27cm).

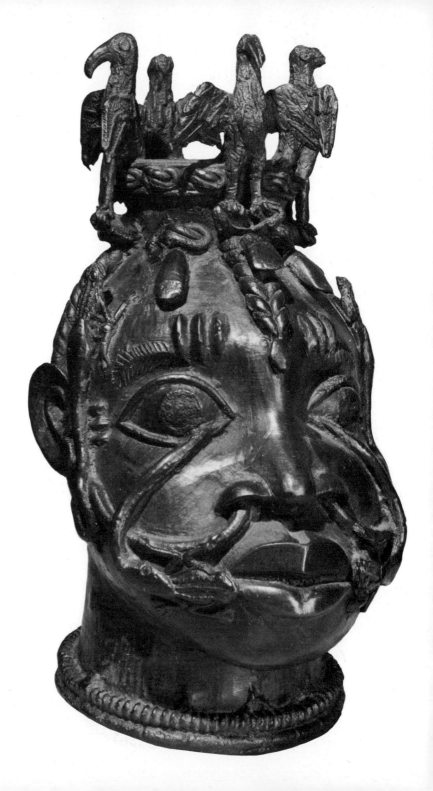

Plate 21
Two bronze headdress masks for the
Ododoa masquerade in the *Agwe* ceremony,
made about 1800. 14¼ and 27¼in (36 and
69cm).

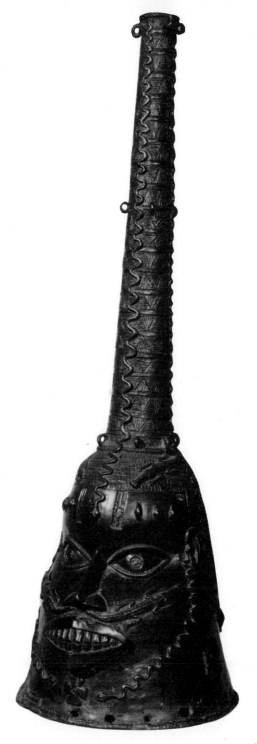

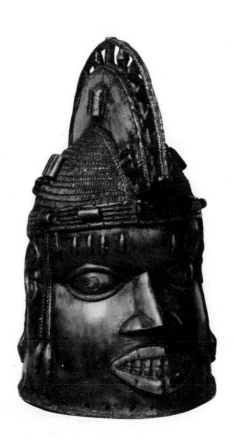

31

Plate 22
The *Ododoa* masquerade being danced,
about 1959, with seven masks made after
the Expedition of 1897.
Photograph: R. E. Bradbury.

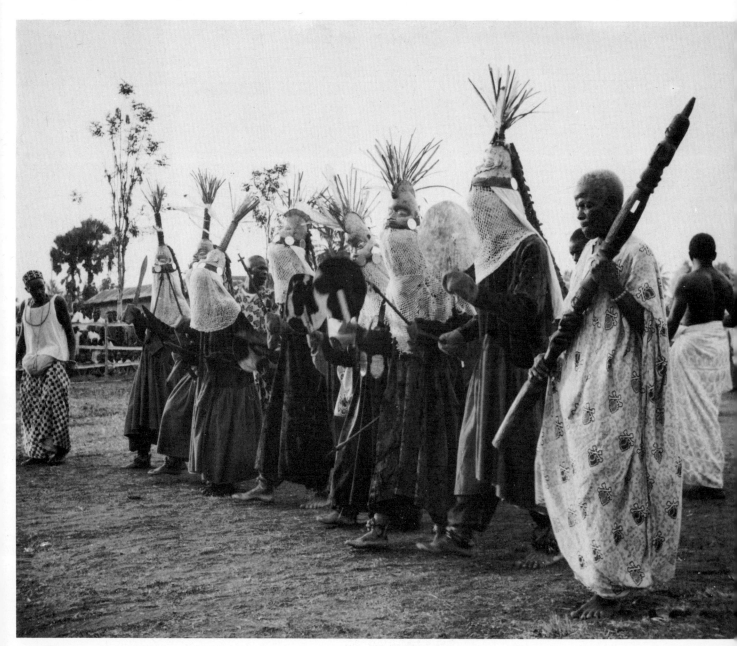

The Portuguese

The Portuguese connection is signalised in bronze figures (Plate 23) of three Portuguese soldiers (right, a crossbowman; centre and left, two arquebusiers or musketeers), possibly cast in commemoration of military assistance given by the Portuguese to Oba Esigye in his campaign against the Ata of Idah (the capital of the Igala Kingdom, about 100 miles to the north-east of Benin), which is thought to have taken place about the year 1515. If so, they were probably made at a later date, perhaps in imitation of previous models which have not survived.

The bronze in the centre is remarkable for showing a matchlock of specifically Japanese form, made between 1543 when the Portuguese introduced firearms into Japan and about 1610 to 1615, when Portuguese influence waned there. The Japanese had introduced various refinements into the design of matchlocks during this period, including the use of the rear sight which is clearly seen on this piece.

Plate 23
Three bronze figures of Portuguese soldiers in sixteenth-century dress, that at right aiming a crossbow; that in the centre a matchlock apparently of Japanese manufacture; and that on left one of Portuguese design. The last is a version done in the Late Period, the others early in the Middle Period. 17, 15 and 13¾in (43, 38 and 35cm).

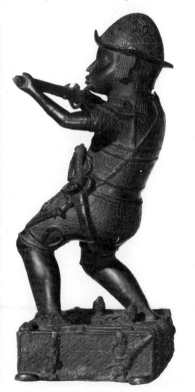
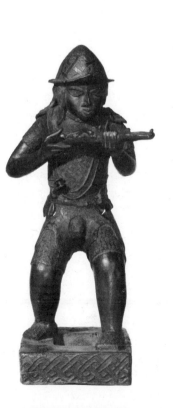
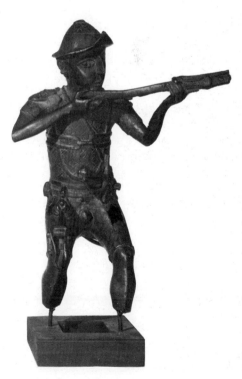

Representations of Portuguese, who enjoyed a privileged position at Benin from about 1486 until the middle seventeenth century, are common at Benin (see the plaques and other pieces at the right of this case), not merely during this period but throughout Benin history up to the British Expedition of 1897 and after. For example, the crossbowman at right and the arquebusier in the centre appear to belong to the Middle Period (*ie* the period in which the rectangular plaques were made, about 1550 to 1650); the arquebusier at left is in the flamboyant style, rather overloaded with ornament, of the Late Period and may date from about 1750, long after the last Portuguese had disappeared from Benin.

These round sculptures of Portuguese are the only form in Benin art which shows the figure in 'spiral' posture instead of the usual rather stiff four-square attitude.

Various other representations of Portuguese include an ivory baton, probably carved in the late nineteenth century, showing a Portuguese figure and a figure of a Bini, illustrating the different treatment of the two races; a hip mask of the kind worn by chiefs on the left hip over the crossing of the kilt; three bells showing the successive degeneration of the design of the Portuguese head; and a brass pipe bowl bearing a similar schematic Portuguese face.

A plaque of the smaller size represents a Portuguese carrying the manilla currency which was probably found in use by then among the Bini and other tribes and was reproduced in Portugal (and, later, elsewhere) for export to Benin. Other plaques represent two Portuguese dignitaries and a Portuguese out hunting with a matchlock and a small dog.

The crossbow

An exhibition case is devoted to crossbows, arrows and a quiver made of two calabashes. The idea of the crossbow probably derives from the Portuguese, unlike the long-bow which is more truly indigenous. The Bini crossbow, however, is much simpler in construction than the European crossbow and also much less effective.

The bronze-casters

The bronze-casters at Benin formed a guild known as *Iguneromwon*, who were allowed to make bronzes only for the Oba. There were several chiefs of the guild, of whom the senior was, and still is, Chief Ineniguneromwon and the second was Ihama. They traced their craft back to the founder of bronze-casting in Benin, Iguegha, who was supposed to have come from Ife in central Yorubaland at the request of an early Oba, Oguola, who probably lived some time in the thirteenth or fourteenth century. The founder of the guild is still the object of cult among the bronze-workers at Benin. They dedicate altars to him and to their own fathers, on which (since they were not allowed bronzes by the Oba) they placed terra-cotta heads which often imitated the style of the Oba's bronze heads. This practice seems to have begun at least as early as the Early Period, as may be seen in the cases illustrating the early bronzes and terra-cottas in the courtyard.

Besides the ancestor heads, there is also a unique terra-cotta altar of the hand, which is similar to those of the Oba in bronze and of the lesser chiefs in wood, but which is ornamented with representations of the tools of the smith's trade.

Plate 24
Chief Osuma in full dress.
Photograph: R. E. Bradbury.

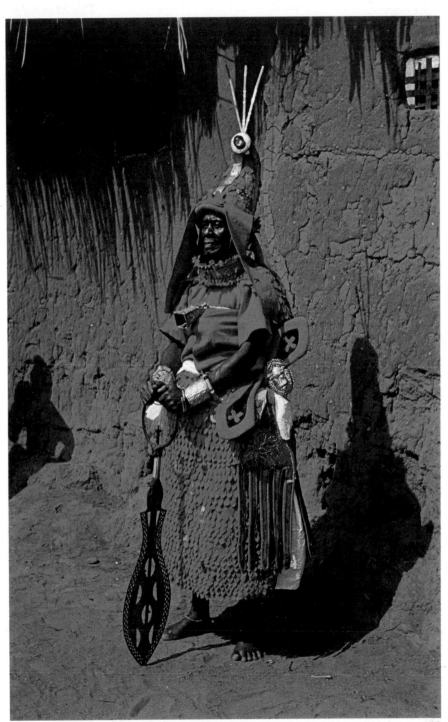

Lost wax

The only technique of casting known at Benin, or indeed in Africa except under European influence, is that known as *cire perdue* or 'lost wax', which was also practised in Europe and elsewhere before the modern invention of the 'sand-box' or bi-valve method. The essence of the lost-wax method is that the artist models in wax the form which he desires to achieve, generally on a fireclay base. It is then enveloped in a fireclay investment to facilitate the translation from wax into bronze. This is effected very simply by heating the mould and pouring out the wax and by pouring in the molten metal from a crucible. The mould has then to be broken open. The important stages in this process are illustrated in the exhibition.

Five masters of the plaque form

There are about a thousand rectangular bronze plaques known to survive, and about one-fifth of these are in the British Museum collection. (In addition, a representative collection of twenty-five plaques were made over to the Nigerian Department of Antiquities shortly after the Second World War.) They are believed to have been placed on wooden pillars more or less as shown in the reconstruction of a court of the Palace. The placing of the narrow plaques on some of the pillars is less certain than that of the larger ones; some of them may have been fixed to horizontal beams.

The majority of plaques do not rise much above a general level of mediocrity, although impressive when seen in bulk. Several hands can, however, be discerned of fine master artists, and several are dealt with in the next few sections.

The Master of the Circled Cross

Of all the plaque masters of the Middle Period of Benin art (which is defined as the period in which the rectangular plaques were being made), this is the most distinctive. First, all his works, and they alone, have a diapered background of circled crosses instead of the otherwise invariable quatrefoil pattern; secondly, he alone cast figures made up of two plaques (the lower portion of the Portuguese figure is in the Museum für Völkerkunde at Vienna); thirdly, although, unlike those of the Master of the Leopard Hunt, his figures adhere strictly to the idea of frontality, they are unmatched for slender grace and beauty (Plate 25). Some twenty to twenty-five of his works are known.

It seems very probable that this artist was the first of all the plaque masters, and was succeeded or joined by two or three of the more original of the other masters; then the more pedestrian artists probably supervened, to make the main body of the plaques.

Plate 25
Bronze plaque by the Master of the Circled Cross, possibly the first of the plaque masters. 16½in (42cm).

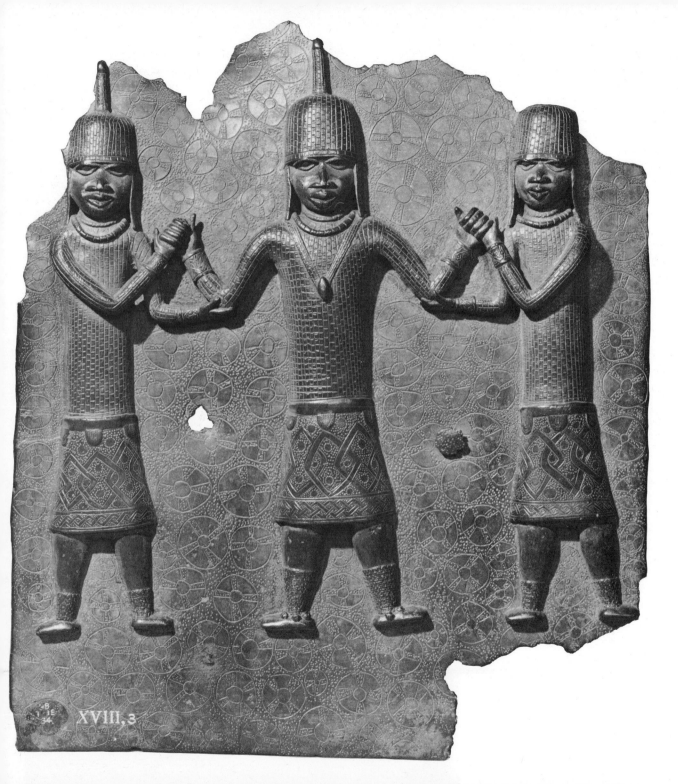

Plate 26
A chief salutes the Oba with his *eben*.
Photograph: R. E. Bradbury.

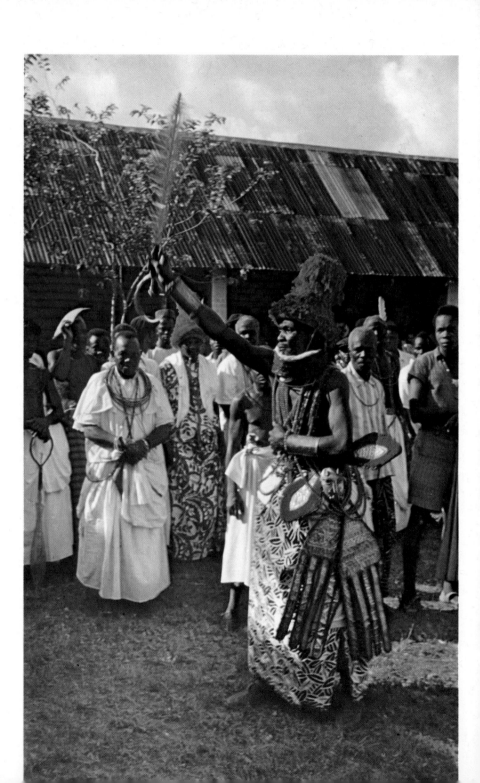

The Master of the Engraved Helmets

This name is derived from other works of the same master in which the ornament on certain helmets, normally three-dimensional, is instead engraved. His figures, as here, are much smaller than usual and in very low relief. This plaque may well represent the great early-sixteenth-century warrior Oba Esigye, who is especially associated with the story of the 'bird of disaster'.

The Master of the Cow Sacrifice

The casting of the form of the cow in front of the human figures argues a considerable virtuosity on the part of this bronze-caster. The neatly arranged hair is also typical of his work. The sacrifice in question is undoubtedly that performed every year by the Oba at his father's altar, the ritual formerly known in pidgin English as 'making father'.

The Master of the Leopard Hunt

Unrepresented in the British Museum collection but impossible to leave out of consideration in any review of the best plaque masters is the Master of the Leopard Hunt, who was probably the finest artist of all. The photographs in the exhibition are of two of his works in the Museum für Völkerkunde at Berlin (about seven of his works in all have been identified). The Benin hunter shooting at birds in a tree is considered by many the most beautiful of all Benin plaques. The leopard hunt is remarkable for the highly original use of 'synoptic vision' – the vegetation being seen as though from above, the leopards in profile and the Portuguese hunters somewhere between the two – producing an effect suggestive of a fine mediaeval tapestry. The artist pays a great compliment to Portuguese sangfroid.

The Battle Master

Among all the 1,000 known plaques no more than twenty or so can be said to have a narrative character, the remainder having the foursquare appearance of a stiffly posed photograph. Although very many of them must commemorate famous victories of Benin arms, it is remarkable that only five or six of them portray warriors in action, of which three are here shown, apparently all by the same hand. All three show Bini warriors in action against enemies who appear to belong to the Western Ibo who live on the west bank of the Niger around Agbor, Kwale and Aboh; two of them wear the characteristic Ibo war hat with ear flaps and all have Ibo facial marks. Some of the figures in each case are treated in a narrative manner, and in one case (Plate 27) the enemy has sustained a massive sword cut across the chest – an extraordinary departure from normal African artistic practice (though severed heads and bodies are not uncommon in other forms of Benin art as a representation of human sacrifice).

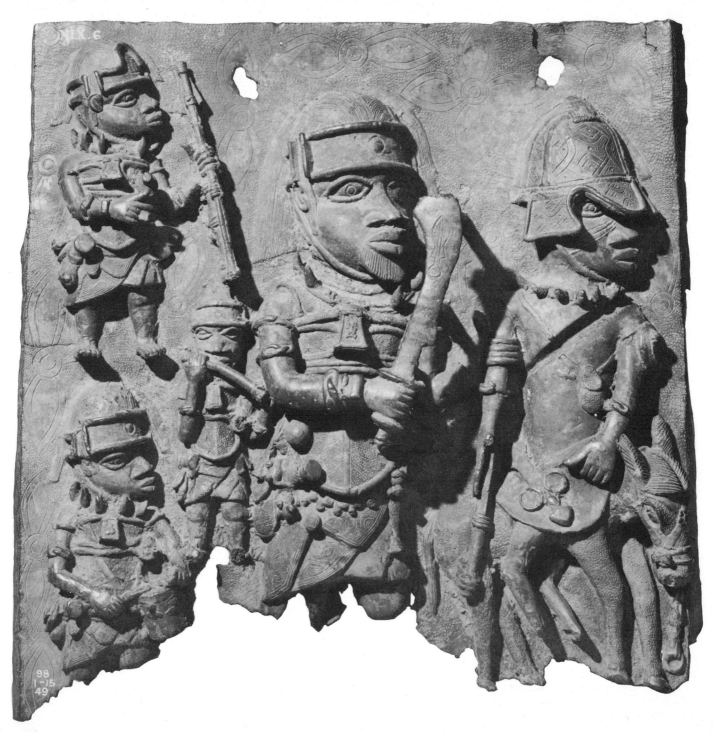

Transference of designs from one medium to another

At Benin, as in many other royal arts, designs and forms of objects appropriate to one medium, such as ivory-carving, were often translated into another medium such as bronze-casting, still retaining the forms and designs appropriate to the first medium. For example, the two ivory objects at left, in the top of which are cups, are conceived in the form dictated by the natural curvature of the tusks, and this shape is commemorated in the bronze version (in the phenomenon known to ethnologists as a 'skeuomorph'). The same translation is seen in three cups of more normal shape.

Shield-shaped plaques

Three plaques are of unusual shape, possibly from doors. The upper two date from the sixteenth or seventeenth century as do all the rectangular plaques in this exhibition. The lower plaque was cast in 1897 to the order of a member of the British Expedition.

Miscellaneous works of art

A staff mount bears a unique representation of a Turk's head. The head is turbaned in what appears to be a Turkish style, but it is perhaps not necessary to assume that a Turk so dressed visited the Benin court. This could have been copied from, for example, a tobacco jar given to the Oba by a European. Issuing from the Turk's head is seen one of the typical dance swords, *eben*, which are used by Benin chiefs in paying homage to the Oba.

It is an excellent work both in style and technique and seems to date from the middle or late eighteenth century, when some fine bronze-casters were working alongside many inferior ones.

A bronze piece is probably for the War Game. The War Game is remembered in tradition but its rules are not. It has been surmised that certain large game boards such as that seen in a photograph in the exhibition were used in this game. This miniature figure is an exquisitely perfect miniature representation of figures of the Oba, or other chiefs, which are found on the rectangular plaques. Its hemispherical base fits exactly into the holes on this board. Only one other such piece is known to survive. Its date is probably about 1600.

A miniature representation of an elephant is almost certainly from the top of one of the Oba's bronze rattle staffs (*ukhurhe*), probably of about the middle eighteenth century.

An ivory kneeling figure of a woman is of the type used by the priests of Oromila, the Bini equivalent of the Yoruba Orunmila or Ifa, the divination cult.

Plate 27
Bronze plaque by the Battle Master, showing a Benin warrior attacking a mounted Ibo, who has sustained a very considerable wound across the chest. $15\frac{3}{4}$in (40cm).

The Altars of the chiefs

Wooden heads were placed by chiefs of the royal lineage on altars dedicated to their male ancestors (*aru-erha*). Such heads were carved since about 1830 in imitation of the bronze heads on the Oba's ancestral altars. Before that date, the chiefs used wooden rams' heads and these can still be found in outlying Edo districts, though not in Benin itself. All these heads, bronze or wood, are called *uhumwelao*.

A wooden ram's head placed by a chief on an altar dedicated to his male ancestors may be from the Bini or from the Ishan to the north. The ram is the animal most often sacrificed to the ancestors.

A wooden cock placed by a chief on an altar dedicated to his deceased mother and the mothers of previous chiefs is to be compared with the bronze cocks used by the Oba for the same purpose.

The altar piece for a chief's cult of his own hand (*ikegobo*) is carved in two parts. The hand, in this ritual context, signifies a man's power of accomplishing things.

The bronze head exhibited in this area probably represents a chief, and is in a provincial style similar to some castings found at Udo, west of Benin. This was at various times an important town rivalling Benin and asserting its independence; at one of these periods it may have defied the Oba's ban on bronze-casting for anyone but himself.

Two bronze figures probably for a chief's ancestral altar were probably too small to come under the displeasure of the Oba.

Three boxes, two of wood decorated with sheet bronze and one of cast bronze, were used by chiefs to present kola nuts to the king for special ceremonies, or to keep beads and other valuables in.

A wooden mask for *ekpo* masquerades is shown. These are not found in Benin itself, but only in surrounding Edo districts.

Wooden objects

A circular wooden stool for a chief is carved from a single block of wood and supported on two intertwined snakes; it probably dates from a little before the Expedition of 1897.

Two carpentered wooden stools are probably for chiefs of the House of Iwebo, one of three chiefs' clubs within the Palace (and the one to which European visitors are admitted as *ex officio* honorary members). They date from shortly before 1897.

A wooden stool probably for one of the chiefs' clubs in the Palace is carved of several pieces of wood and fitted together, shortly before 1897. Joinery is a technique learned from Europeans.

A wooden chest for storing ceremonial costumes and other valued possessions was apparently found in the bedchamber of Oba Ovonramwen in 1897, and said to have been carved in 1891. It almost certainly contained the ivory masks, bells and armlets of which some are displayed in a case in the courtyard. Although its form imitates that of European carpentered chests, it is in fact carved (apart from the lid) from a single block of wood. It is thus classified by ethnologists as a skeuomorph.

There are also a number of wooden boxes and box lids used by chiefs for keeping things in, especially the kola nuts used for the ceremonial presentations of offerings to visitors and to gods and ancestors.

The Ife–Benin succession

There is a strong tradition at Benin which says that the Benin tradition of bronze casting was imported from Ife at some time after the kingship itself had been introduced from there. Until about the middle of the nineteenth century, the spiritual suzerainty of the Oni of Ife (known in Benin as the Oghene of Uhe) was formally acknowledged by the ancient custom of sending messengers to Ife to announce the holding of the Oba's annual sacrifices, and, also, when an Oba died, of sending his head to Ife for burial. While the actual execution of these customs lapsed in the nineteenth century they were replaced, for example, by one in which the Oni of Ife is impersonated by a Benin chief (in 1958 Chief Ihama, as is seen in the photograph), who receives, on the outskirts of the town, a message brought by another chief from the Oba to say that he has completed his ceremonies, and who then gives to this messenger a box containing a gift for the Oba as a sign of his approval.

According to Benin oral history, it was in Oba Oguola's time, perhaps in the thirteenth or fourteenth century, that a request was sent to the Oni of Ife for a master bronze-caster to be sent to Benin to teach the Benin craftsmen how to cast bronze heads, which according to the story had till then been made at Ife for the Obas of Benin. The Oni sent Igue-igha, or Iguegha, who founded the Benin bronze industry.

Confirmation of this story is found especially from two sources: first, one small figure found at Benin which is undoubtedly in the Ife style (although it may have been made perhaps by Iguegha at Benin); and, secondly, from recent excavations by Professor Frank Willett at the place called Orun Oba Ado at Ife, where heads of Obas of Benin were traditionally buried. A small piece of Benin bronze work was found in these excavations, but, more important, the excavations were found to relate in their lower levels to a period about AD 1000–1200 (and indeed one radiocarbon date related to a period about AD 600).

The art of Ife was more naturalistic than that of Benin, but the Early Period at Benin is the most naturalistic, and is not very far short of the naturalism of Ife except that some features such as the ears have become schematic. The British Museum is fortunate to possess the only Ife bronze head outside Nigeria, and this is exhibited here, as are some of the copies made in 1948 from the main body of the heads which belong to the Oni of Ife; an original terra-cotta head and some fragments, and copies of others, are also shown, as is the most perfect of the well-known quartz stools which preserve the shape of ritual box-thrones of bark. But in addition, it is possible to show here, in the first few weeks of this exhibition, the finest Ife bronze work so far known, the seated figure of Tada, which has reposed on the banks of the Niger in Nupe country for five centuries or more (Plate 28). Thereafter, the original having been returned to the Nigerian Department of Antiquities, it will be replaced here by a bronze copy.

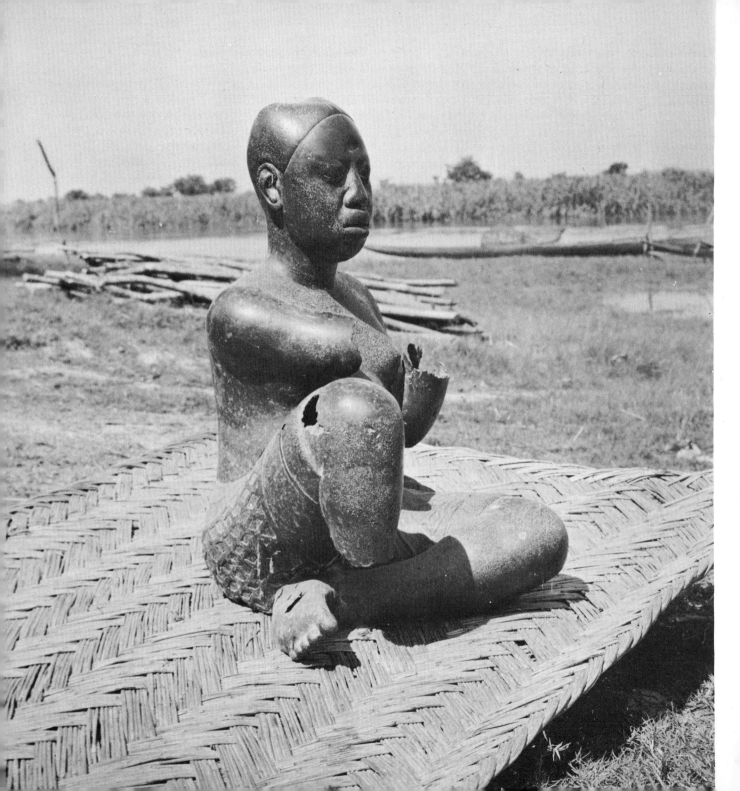

The Nok Culture

In the attempt to extend the time scale of Benin art from the forged antiques of the present day backward through Ife art – whose directly ancestral status may be accepted as adequately established in art history – to the earliest times, the Nok Culture of the central area of Nigeria is now presented as the only candidate at present available for the ancestry of Ife art – although whether the ancestry is direct or collateral remains to be seen. Earlier occurrences of pottery, such as one near Akure in eastern Yorubaland, have been reported, but none of sculpture. The art of Nok is in fact the only sculpture in sub-Saharan Africa which can be firmly dated before the birth of Christ; radiocarbon dates cover the period c 500 BC–AD 200.

The Nok Culture is close to the beginning of the Iron Age, and may indeed owe its rise to the introduction of iron among peoples who till then were using stone tools. These peoples were at least in some respects more homogeneous than they are now, if we may judge by the common elements of style which unite the sculpturally very varied terra-cotta works of art from an area 300 miles long from west to east, and some 150 miles from north to south. In its range from almost complete naturalism to abstraction, it may almost be called pan-African. It is probable that the social structure of the Nok people was much as it still is among the 'pagan' tribes of the area, a hill village economy very different from the highly stratified society of the Yoruba, who must even then have had tendencies to urbanism. (The main populations of the Nigerian area are thought to have occupied their present habitat for some 4,000 to 5,000 years).

No Nok terra-cottas are owned by collections outside Nigeria, but a number of copies are exhibited.

Plate 28
The seated figure of Tada, photographed on the banks of the Niger. It is probably the finest Ife work yet found. 20in (51cm).
Photograph: W. B. Fagg, 1958.

The Bini-Portuguese ivories

Bini-Portuguese ivories are a subdivision of Afro-Portuguese ivories, which are saltcellars, spoons, forks, dagger handles and hunting horns made by African craftsmen in the sixteenth and early seventeenth centuries.to commissions for Portuguese royalty and nobility. (The other main subdivision, accounting for about three-quarters of the known pieces, is the Sherbro-Portuguese ivories, made by Bulom or Sherbro craftsmen from Sherbro Island, Sierra Leone.)

The Afro-Portuguese ivories were positively identified as of Sherbro and Bini origin only in 1960; it had been previously thought that they must have a single origin. The similarity between the styles of design employed in the Bini-Portuguese ivories and in the work of the *Igbesamwan,* or guild of ivory-carvers at Benin, might not be decisive, except in the case of the hunting horn seen here, which is to be considered together with another horn from the Emperor of Austria's collection in the Vienna Museum für Völkerkunde, and a third in the Rautenstrauch-Joest Museum at Cologne. The Vienna specimen includes an unmistakable figure of an Oba in Benin court dress, complete with the horn-like upward projection from the skirt which is found nowhere else (and incidentally bestriding an elephant – a most interesting link with the Sherbro-Portuguese style). These horns have indeed a clear identity of decorative motifs with the great tusks on the Oba's ancestral altars, while they share other elements with the saltcellars (which, unlike Sherbro-Portuguese examples, all have two chambers, the second being presumably for pepper or spice). The spoons can similarly be connected with Benin work. In all these cases, the Benin predilection for *horror vacui* – the tendency for ornament to expand to fill the space available for it – is extremely well marked.

No Afro-Portuguese ivory has been found in modern times in Africa, although Professor Alan Ryder has found an early Portuguese record of one being despatched from Benin. At the same time there is some evidence favouring the view that Sherbro and Bini craftsmen were working closely together in one place, and this could have happened in Portugal or at some place on the West African coast.

The salt (Plate 29) bearing figures of two Portuguese grandees with the cross of the Military Order of Christ on their breasts and on the lid a ship, is one of the two finest known of Benin salts (the other is in the National Museum, Copenhagen). The middle section of another version by a different hand is beside it. The third salt is an example of the other principal subject, two horsemen with a naked man among the foliage behind; the lid has been replaced in more modern times. The horn bears the Portuguese arms and is side-blown on the outside of the curve (a Benin peculiarity), though the end is broken off. The four spoons seem to owe the beauty of the bowl shape to Portuguese rather than African inspiration.

Plate 29
Ivory salt with two chambers, carved to Portuguese commission in the sixteenth century by a Benin craftsman and representing two Portuguese dignitaries with their attendants, surmounted by a ship with a man with a spy glass in the crow's nest. 11¾in (30cm).

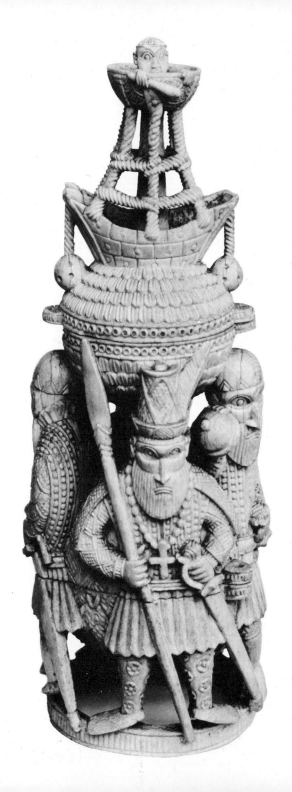

Plate 30
The Chairwoman of one of the ladies'
clubs of Benin attending one of the Oba's
annual ceremonies.
Photograph: R. E. Bradbury.

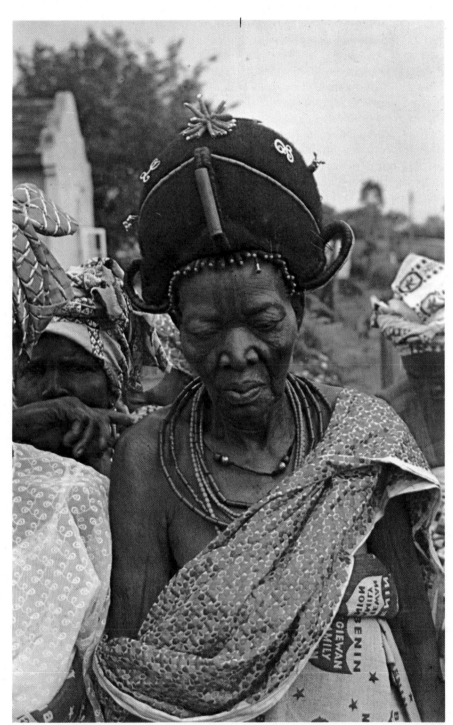

The Lower Niger Bronze Industry

This intentionally cumbrous appellation was allotted some ten years ago to a group of bronzes in a number of different but apparently related styles, most of which had previously been accepted as of Benin origin, in the hope that the name will be quickly dropped as soon as archaeologists or ethnologists can discover their actual places of origin.

The largest works in the group are nine of the ten Tsoede bronzes from Jebba, Tada, etc (the tenth is the seated figure of Tada, an Ife work). The Gara, or standing figure of a chief, of Tada is exhibited, at first in original and afterwards in replica, by permission of the Nigerian Department of Antiquities. A small figure from Bida in the British Museum collection may well be associated with this group. They are said to have been brought up the Niger from Idah, the Igala capital, to the Nupe country by Tsoede, the legendary founder of the Nupe kingdom. Their iconography shows some relationship with Benin work.

Another style is that associated with the figure of a hunter returned from the chase bearing an antelope on his shoulders, and with a famous pair of heads of which one is also in the collection. The small bronze warrior seen in Plate 31 is one of the liveliest in this style. These have claims to be the best of all the works of the group. Other styles are the Andoni Creeks style, the Forcados River style, and another marked by bell-shaped horned heads.

Finally, the remarkable style of Igbo-Ukwu near Awka in Ibo country should be included since it falls within the stylistic range of the group. It must be presumed, until proved otherwise, that it was made there, since it has not been found elsewhere. It appears to have been associated with the divine king (the only one in Ibo country) of Nri. Its rich ornamentation suggests a rococo-like phase of art, so it is all the more surprising that radiocarbon tests show it to be the oldest known occurrence of bronze in sub-Saharan Africa – about the eighth to tenth centuries AD.

Plate 31
Bronze staff mount (?) with a crouching figure of a warrior, in the style of the Lower Niger Bronze Industry. 5¼in (14cm).

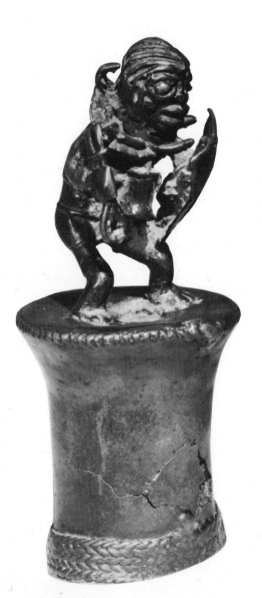

Divine kingship elsewhere in Africa

To give some impression of the great range of the arts of kingship in Africa – since the Benin kingship is in many ways *sui generis* – five other forms of kingship have been selected for summary illustration.

Yoruba kingship, even though the Benin monarchy was derived from it, is very different from it. Most large Yoruba towns have their Obas (with a wonderful variety of titles), each of whom is at the pinnacle of a pyramidal social structure. Beneath the Oba are chiefs with territorial and lineage responsibilities, and his power is greatly circumscribed by the obligation to consult them, and formerly also the elders of the Ogboni Society. The Oba is in a very real sense – like a modern European monarch – the representative of his people. Moreover, the kingship rotates among three or four families of the royal lineage, so that the word 'dynasty' has little meaning. This delicate system of checks and balances, when transplanted to Benin, could not take root in the alien infrastructure – a village economy rather of the Ibo type – and the early Obas of Benin were forced – or had the opportunity – to abandon most of the safeguards in favour of an absolutist regime, with descent of the kingship by primogeniture.

The Yoruba arts of kingship are represented here by the magnificent doors by Olowe of Ise from the Palace at Ikere-Ekiti, commemorating the reception by the Ogoga of Ikere of the first British administrator, a Captain Ambrose, in about 1895 (Plate 32); by house posts, mainly from the great carving centre of Efon-Alaye; by beaded crowns, staffs and fans and by ivory ornaments; and by two of the great drums from Ogboni houses around Ijebu-Ode, symbolising the power of the Ogboni Society.

Zimbabwe in Rhodesia is the grandest architectural expression of kingship in Africa south of the Sahara; lesser stone buildings in similar styles are widespread in southern Angola, Rhodesia and Mozambique. They are the work of the Bantu-speaking tribes, and the buildings at Zimbabwe were begun about a thousand years ago, though they appear to have assumed something like their present form only in the last three or four centuries. There is little direct evidence of the manner of use of the buildings but it seems almost certain that they may be interpreted thus: a royal palace (the Elliptical Building) surrounded by lesser stone buildings, on the plain below; and a ceremonial centre (the Acropolis) on the rocky height above, which formerly included a shrine in which each king probably set up a soapstone pillar surmounted by a bird, in his own honour or that of his predecessor. A cast is shown of one of these, besides an original pillar lacking its top. There is also an original and a cast of soapstone figures found at Zimbabwe (Plate 34).

Plate 32
Pair of carved wooden doors from the Palace at Ikere-Ekiti, eastern Yorubaland, carved by Olowe of Ise and representing the reception of the first British administrator, Captain Ambrose, by the Ogoga of Ikere about 1895. 82in (213cm).

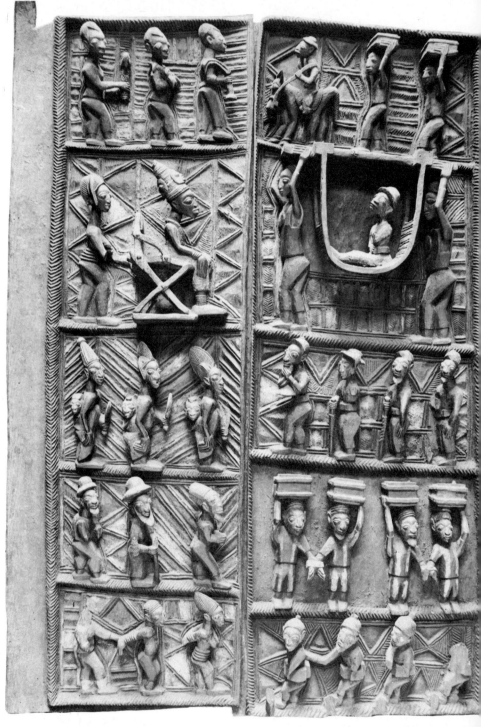

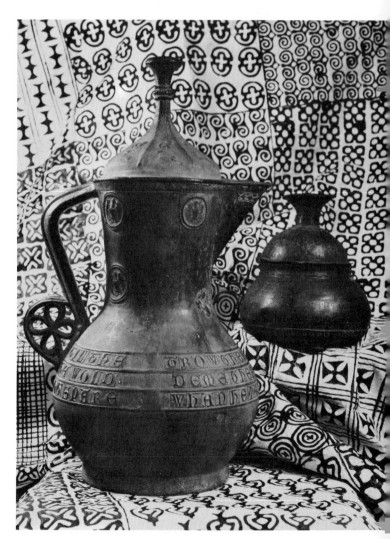

Ashanti kingship is doubtless the most easily recognis-
able to Europeans because alone among African
monarchies it has in recent centuries disposed of
virtually unlimited supplies of gold, and has utilised
it most lavishly to adorn the trappings of royalty.
Mystical beliefs about the nature and function of gold
(which would hardly be recognised in Zürich) have not
prevented a certain artistic deterioration (somewhat
similar to that in Benin bronze work over the past two
or three centuries) under its dazzling influence,
especially since the Ashanti war of 1873 opened the way
to a more fully materialist appreciation of it – with the
result that by the 1896 campaign many of the royal
ornaments were no longer of solid gold, but rather crude
wood carvings overlaid with gold foil. But in truth the
mystical association between the divine kingship and
gold can never have been the whole story: from far back
in mediaeval times this part of Guinea had provided the
substance of 'the golden trade of the Moors'; and
mysticism is not for export.

 That trade may perhaps account for the finding in
1896 on one of the Asantehene's shrines of a magnificent
English bronze ewer bearing badges of King Richard II,
together with a lesser ewer, also of about 1400. The
peculiar form of lid of the former piece may have
influenced that of one of the characteristic types of
kuduo, or Ashanti bronze ritual vessel (Plate 33).

 Ashanti society is matrilineal and the kingship equally
descends in the female line.

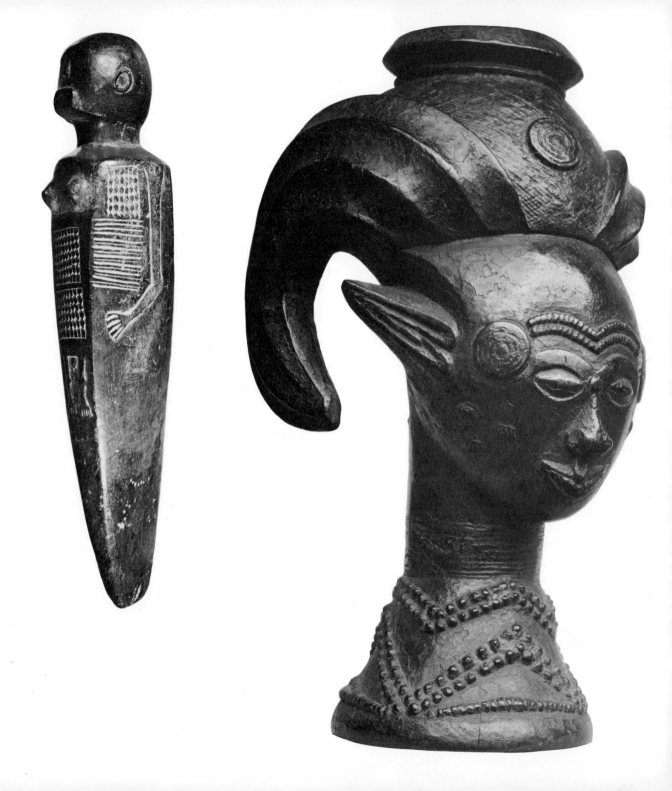

Plate 34
Soapstone figure of a woman said to have
been found in the ruins of Zimbabwe;
perhaps 100–200 years old. 16in (41cm).

Plate 35
A ceremonial wooden cup for palm wine,
made for the use of the King of the Bakuba,
Congo-Kinshasa. 10¾in (27cm).

Bakuba kingship claims to be the oldest in Negro Africa, with a king list of 122 names, which on a normal allowance would place its genesis about AD 500. In fact, it is improbable that much reliance can be placed on this list before about 1500 or 1600. It is unlikely to be a complete fabrication, but often an interloper king may have wished to ennoble his ancestors and strengthen his own claim to the throne by adding some of their names to the record. And there are many other possible inflationary techniques; yet we must still assume that this is a kingdom of very ancient standing.

The Bakuba first appear in history about 1600, the time of their great king Shamba Bolongongo, when a massive infusion of design from the Kingdom of Kongo near the coast can be demonstrated from material culture. Among other things, the practice of having a 'portrait' of the king carved during his lifetime, to be used in the installation of his successor (chosen by matrilineal succession), first began then, and the British Museum has what is according to tradition the first portrait of all, that of Shamba himself, besides two others (Bope Pelenge and Misha Pelenge Che) dating from about 1800. Several fine works directly associated with the kingship are shown, and the Museum owes much both to Emil Torday, the collector, and to King Kwete Peshanga Kena, who gave them to Torday during his stay among the Bakuba from 1907 to 1910.

Palm-wine cups carved with ram horns are reserved to the use of the King (Plate 35).

In tradition, the ideal of kingship among the Bakuba is remarkable for the humanity and far-seeing wisdom which are its most desired attributes.

Grasslands kingship in Cameroon seems in some ways most comparable in the degree of power exercised by the king to that of the Yoruba of Western Nigeria. The small kingdoms, often embracing only three or four villages, enjoyed a fairly high degree of autonomy, and this was not too seriously disturbed by warfare. In fact, the Grassland tribes seem to have treated their area as though it were occupied by a single tribe, or super-tribe. It may be that, given another century or two of natural development, the three main stocks, the Tikar, the Bamum, and the Bamileke, would have coalesced to the point where they would have been recognized as a single tribe, with local variations like those of the Yoruba.

The palaces of the Fons or kings are probably the most impressive wooden palaces in Africa, the great porches sometimes rising to 30 feet or more with elaborate wood carvings in the vigorous styles of the area. The entrance of a Bamileke palace (Plate 36), having in front of it pillars supporting the porch, somewhat similar to the big posts from Mbum, the throne from Babanki, the chief's bed from the Bamenda area and two masks from the Bamum are typical in general of the royal styles of the Grasslands.

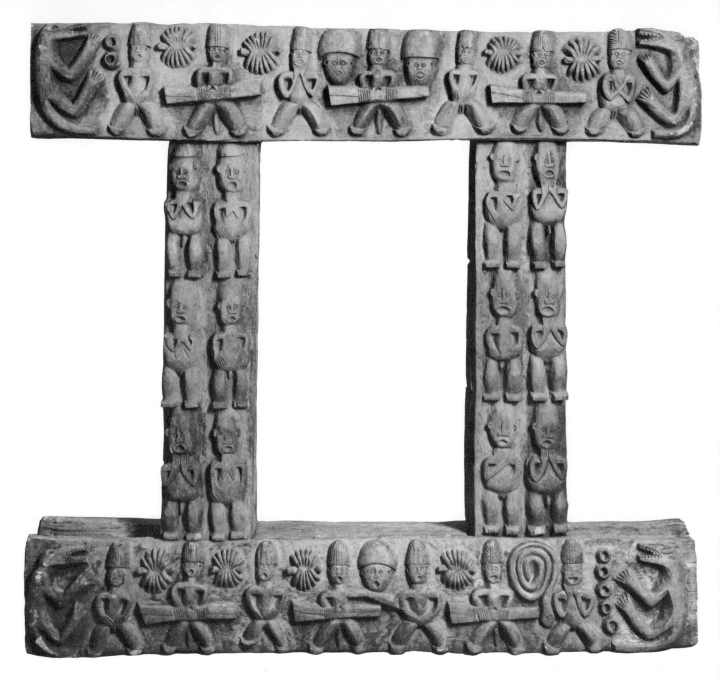

Plate 36
Carved wooden door frame from a Palace
of the Bamileke of the Grasslands of
Cameroon. 79in (200cm).

List of exhibits

Divine kingship as represented at Benin
Coral bead cap 1898 6–30 5
Coral bead tunic; Mrs H. G. Beasley 1944 Af4 63
Coral bead skirt 1898 6–30 4
Five carnelian necklaces and two carnelian bracelets; Mrs H. G. Beasley
1944 Af4 62a–g
Coral bead fly whisk with carnelian handle 1898 6–30 3
Brass arm rest; Wellcome coll 1954 Af23 403
Three rectangular plaques; Foreign Office 1898 1–15 29, 30, 190
Shield-shaped plaque; Wellcome coll 1954 Af23 293
Sheet-brass figure; Mrs M. B. Jennings 1961 Af17 5
Ceremonial sword (*eben*); Friends of the British Museum 1903 12–16 1
Another (*ada*) 1949 Af46 166
Bronze bird staff; Lady MacDonald 1929 1–5 2
Another; Sir William Ingram 1897 10–11 6
Another; P. Tarbutt Esq 1941 Af2 1

The royal leopards
Pair of ivory leopards with copper spots; lent by HM The Queen
Five bronze plaques; Foreign Office 1898 1–15 80, 171, 199, 200, 201
Sheet brass leopard 1954 Af21 1
Two bronze hip masks; Wellcome coll 1954 Af23 286, 780
Another 1947 Af18 42
Another; Mrs Webster Plass 1956 Af27 227
Bronze waist mask; H. N. Thompson Esq 1908 12–5 6
Another; Wellcome coll 1954 Af23 782

The Oba's Palace
Bronze plaque; Foreign Office 1898 1–15 46
Bronze snake's head 1954 Af8 1
Section of bronze snake's body 1964 Af3 1
Iron and brass door key 1897 531
Bronze door key 1904 10 18 4
Two door keys, iron and bronze, and bronze; Mrs H. G. Beasley
1944 Af4 20, 32

The Oba's ancestors: the Early Period
Bronze head 1897 12–17 3
Another; Mrs A. W. F. Fuller 1963 Af9 1
Bronze head of a queen-mother; Sir William Ingram 1897 10–11 1
Terra-cotta head; Wellcome coll 1954 Af23 281
Miniature bronze head; Mrs Webster Plass 1956 Af27 295

Another, smaller; A. G. Coles Esq 1948 Af18 1
Bronze hip mask 1962 Af20 3

Ancestor altar of the Middle Period
Bronze head 1897 12–17 2
Another; E. J. K. Cordner Esq 1903 10–22 4
Another; Mrs H. G. Beasley 1944 Af4 11
Ivory tusk (placed on head 1903 10–22 4) NN
Another (on 1944 Af4 11); Sir William Ingram 1897 12–24 4
Another (on 1897 12–17 2); Sir William Ingram 1897 12–24 2
Another; Lady Campbell 1922 3–11 1
Two others; Miss Pinnock bequest 1921 6–15 1, 2
Two others 1897 565, 649
Another NN
Bronze hornblower; E. J. K. Cordner Esq 1903 10–22 1
Another 1949 Af46 150
Bronze rider; Mrs H. G. Beasley 1944 Af4 13
Bronze cross-bearer 1949 Af46 157
Bronze stool; Sir John Kirk bequest 1923 10–13 1
Bronze lid for a bowl 1949 Af46 160
Three wooden staffs; Mrs H. G. Beasley 1944 Af4 69, 74, 76
Another; Wellcome coll 1954 Af23 357
Ceremonial sword (*eben*); Mrs H. G. Beasley 1944 Af4 19
Another 1949 Af46 168
Another; Friends of the British Museum 1903 12–16 2
Ceremonial sword (*ada*) 1900 5–20 1
Two bronze bells 1897 498 499
Another 1905 12–1 4
Four others; Mrs H. G. Beasley 1944 Af4 28–31
Bronze fluted vessel (part) 1900 7–20 19

Ancestor altar of the Late Period
Bronze head 1897 12–17 1
Another; E. J. K. Cordner Esq 1903 10–22 3
Three others; Mrs H. G. Beasley 1944 Af4 1–3
Another; Admiralty 1961 Af9 1
Ivory tusk (on bronze head 1944 Af4 1); Admiralty 1961 Af9 2
Another (on 1961 Af9 1) 1914 8–4 1
Another (on 1944 Af4 2); Mrs H. G. Beasley 1944 Af4 77
Another (on 1944 Af4 3) NN
Another (on 1897 12–17 1) NN
Another NN

Two others; Sir William Ingram 1897 12–24 1, 3
Another (partly burned in a fire) NN
Another (almost uncarved) 1949 Af46 171
Bronze rider 1903 7–18 1
Bronze cross-bearer 1905 12–1 1
Two bronze figures 1897 550 564
Another; Mrs H. G. Beasley 1944 Af4 6
Bronze globular vessel 1949 Af46 159
Bronze annular stand 1949 Af46 159a
Bronze bowl with lid: Wellcome coll 1954 Af23 296
Wooden bowl with brass ornament 1902 5–16 11
Ivory rattle staff 1898 6–30 1
Bronze rattle staff; Wellcome coll 1954 Af23 343
Wooden rattle staff; Mrs H. G. Beasley 1944 Af4 73
Another 1904 10–18 6
Another 1952 Af7 41
Wooden staff 1949 Af46 176
Another; Wellcome coll 1954 Af23 359
Ceremonial sword (*eben*) 1949 Af46 167
Another; Mrs H. G. Beasley 1944 Af4 18
Another; Wellcome coll 1944 Af2 1a
Ceremonial sword (*ada*); Mrs H. G. Beasley 1944 Af4 14
Another 1897 509
Five bronze bells; Wellcome coll 1954 Af23 336–340
Two others 1900 7–20 13, 14
Another 1947 Af8 52
Another; Mrs J. Trew 1956 Af21 1
Two others NN
Bronze lamp 1900 7–20 18

The Altar of the Hand
Bronze altar piece; Sir William Ingram 1897 10–11 2
Ivory tusk mounted thereon; Wellcome coll 1954 Af23 407

The Altar of the Oba's Mothers
Bronze altar piece 1897 501
Two bronze heads: Mrs H. G. Beasley 1944 Af4 4, 5
Bronze cock 1898 10–25 2

The royal ablutions
Bronze leopard aquamanile; A. C. Goolden Esq 1949 Af38 1
Another 1911 6–20 1
Bronze ewer 1899 5–19 1
Bronze ram aquamanile; Wellcome coll 1954 Af23 294

The King's Ivory Treasure
Double bell; Mrs Webster Plass 1963 Af4 1
Striker for bell; Lady Epstein 1964 Af7 1
Mask 1910 5–13 1
Leopard costume ornament 1910 6–18 4
Lid of an annular box inlaid with bronze; Louis Clarke Esq
1918 4–13 1
Pair of interlocking double armlets inlaid with bronze 1910 5–13 2, 3
Pair of armlets inlaid with bronze 1922 3–13 3, 4
Another (not inlaid) 1922 3–13 5, 6
Single armlet inlaid with gilt bronze 1922 7–14 1
Another (not inlaid) 1949 Af46 179

Court dress
Leather tunic covered with red flannel 1897 520
Bronze wand 1897 507

Adornment
Bronze bracelet 1949 Af46 164
Another; Wellcome coll 1954 Af23 367
Bronze cuff; Wellcome coll 1954 Af23 360
Another NN
Another; Mrs H. G. Beasley 1944 Af4 26
Two wooden combs 1947 Af18 59, 60
Ivory comb 1958 Af10 2
Two iron hairpins 1902 5–16 25, 26
Bronze pendant 1949 Af46 184
Coconut ring; Rear-Admiral Brian Egerton 1957 Af14 15
Ivory ring 1920 11–6 24
Bronze ring 1897 535
Four ivory pendants; Lady Campbell 1922 4–5 1–4
Three others 1898 10–22 1–3
Another; Mrs H. G. Beasley 1944 Af4 58
Nine glass beads; Wellcome coll 1954 Af23 391a–g, 392a, b
Five bronze crotals 1949 Af46 183
Bronze pendant figure with crotal and sword; Wellcome coll
1954 Af23 284a, b

Dress ornaments in bronze
Three hip masks; Wellcome coll 1954 Af23 287, 289, 781
Another; Alban Head bequest 1931 11–18 80
Another 1949 Af46 806
Waist plaque; E. Croft Murray Esq 1934 10–25 2
Another 1904 10–18 2
Three others 1897 12–17 4, 5, 6
Two others; J. F. Robinson Esq 1970 Af11 1, 2

The King's Music
Ivory horn; H. Beddington Esq 1921 2–14 3
Another; H. Beddington Esq 1921 2–14 3
Bronze rod ending in a crotal 1897 532
Another 1947 Af8 4
Small bronze bell 1900 7–20 15
Bronze rattle with iron clapper 1947 Af8 5
Wooden flute or hunter's whistle 1947 Af18 61
Wooden linguaphone 1897 515
Musical bow 1900 7–20 20
Bronze costume plaque; E. Croft Murray Esq 1934 10–25 1
Small double-membrane drum NN
Double-membrane drum; Wellcome coll 1954 Af23 405
Single-membrane drum; Wellcome coll 1954 Af23 404
Five bronze plaques 1898 1–15 68, 115, 128, 129, 135
Another 1961 Af18 1

The Spirit Cult
Bronze helmet mask with tall 'spout'; Mrs H. G. Beasley 1944 Af4 12
Another, with crest instead of spout 1898 10–25 1
Bronze head 1948 AF9 1
Bronze sheath for a knife 1897 510
Bronze staff (upper half only); Norman Clough Esq 1938 7–2 1
Two bronze horns 1900 7–20, 8, 9

Three bronze horns; Wellcome coll 1954 Af23 332–4
Thirteen ivory horns; Wellcome coll 1954 Af23 319–331
Another 1900 7–20 4
Bronze hip flask; Wellcome coll 1954 Af23 288
Another 1957 Af29 1
Another 1897 529
Two large bronze rings; Wellcome coll 1954 Af23 369, 370
Pair of small iron bells 1920 11–6 26
Nine iron rattles; Wellcome coll 1954 Af23 344–352
Two others 1920 11–6 30, 31
Large bronze ring 1950 Af27 1
Another; Sir William Ingram 1897 10–11 5
Bronze miniature tableau; Wellcome coll 1954 Af23 783
Two wooden headdresses from Ughoton; Wellcome coll
1954 Af13 401, 402
Another; Mrs H. G. Beasley 1944 Af4 31
Bronze staff, heavily ornamented 1904 10–18 1
Bronze staff surmounted by a single figure 1909 6–26 13
Another, a series of three figures, one on top of the other 1949 Af4 1
Another with three figures 1902 5–16 31
Four iron staffs; Wellcome coll 1954 Af23 353–356
Another NN

The Portuguese
Bronze arquebusier; Mrs H. G. Beasley 1944 Af4 7
Another 1928 1–12 1
Bronze crossbowman 1949 Af46 158
Bronze plaque; Mrs H. G. Beasley 1944 Af4 10
Two others; Foreign Office 1898 1–15 1, 11
Another (described by donor as a modern work by Chief Ine the principal
brass-worker in 1897); Major H. P. Gallwey 1899 7–10 1
Ivory baton; Wellcome coll 1954 Af23 787
Bronze hip mask 1947 Af18 41
Bronze bell 1900 7–20 12
Another 1934 3–13 8
Another 1920 11–6 20
Bronze pipe bowl; Wellcome coll 1954 Af23 376

The crossbow
Wooden crossbow; Mrs E. M. Bickford 1960 Af22 2
Another 1920 11–6 7
Crossbow darts 1897 524
Calabash quiver 1900 7–20 21

The Bronze-casters' Ancestor Altar
Large terra-cotta head; Mrs H. G. Beasley 1944 Af4 68
Terra-cotta leopard's head; W. H. Roberts Esq 1935 6–5 1
Terra-cotta altar piece; Wellcome coll 1954 Af23 282
Small terra-cotta head; W. H. Roberts Esq 1935 6–5 2
Fourteen others; Wellcome coll 1954 Af23 268–281

Lost wax
Series, illustrating the technique of *cire-perdue* bronze-casting;
Major Powell-Cotton 1932 12–4 1–6
Four tools used in *cire-perdue* casting; Major Powell-Cotton
1933 2–7 1–4
Beeswax; Major Powell-Cotton 1933 2–7 5

Five masters of the plaque form
The Master of the Circled Cross: four bronze plaques; Foreign Office
1898 1–15 2, 34, 35, 36
The Master of the Cow Sacrifice: one plaque; Foreign Office
1913 12–1 1
The Master of the Engraved Helmets: one plaque; Foreign Office
1898 1–15 44
The Battle Master: three plaques; Foreign Office 1898 1–15 47, 48, 49
(The Master of the Leopard Hunt is represented by photographs only)

Bronze plaques
These are displayed on wooden columns around the exhibition and for
the purposes of this list these columns are numbered in a clockwise
direction beginning in the corner beside the Middle Period ancestor altar.
The plaques are listed from top to bottom, and 'front' means the wide
face of the pillar facing into the courtyard.

Column 1
Front 1898. 1–15. 60, 21, 23, 112, 85; Left 1898. 1–15. 203, 1908. 12–5.
3, 1898. 1–15. 143, 139, 1901. 4–20. 1; Rear 1898. 1–15. 124, 150, 137,
50, 70; Right 1898. 1–15. 192, 196, 197, 187, 193

Column 2
Front 1898. 1–15, 121, 63, 153, 26, 87; Left 1898. 1–15. 15, 163, 102, 1903.
10–22. 7, 1944. Af4 8; Rear 1898. 1–15. 136, 28, 52, 39, 147; Right 1898.
1–15. 84, 9, 7, 6, 3

Column 3
Front 1898. 1–15. 91, 109, 130, 151, 42; Left 1898. 1–15. 66, 72, 1949.
Af4 9, 1898. 1–15. 162, 138; Rear 1898. 1–15. 18, 5, 40, 86, 79; Right
1908. 12–5. 1, 1898. 1–15. 167, 1903. 10–22. 8, 1898. 1–15. 56, 69

Column 4
Front 1898. 1–15. 38, 142, 89, 1898. 12–11. 2, 1898. 1–15. 123; Left 1898.
1–15. 183, 194, 185, 180, 182; Rear 1898. 1–15. 141, 140, 1903. 10–22.
5, 1898. 1–15. 99, 120; Right 1898. 1–15. 188, 191, 174, 189, 198

Column 5
Front 1898. 1–15. 58, 76, 73, 145, 133; Rear 1898. 1–15. 16, 131, 157,
172, 149

Column 6
Front 1898. 1–15. 155, 6, 118, 105, 65; Left 1898. 1–15. 32, 1908. 12–5.
4; Rear 1898. 1–15. 107, 64, 53, 81, 77; Right 1898. 1–15. 177, 176, 13,
8, 168

Column 7
Front 1898. 1–15. 108, 45, 106, 134, 95; Rear 1898. 1–15. 103, 78, 132,
173, 122

Column 8
Front 1898. 1–15. 117, 165, 148, 83, 93; Rear 1898. 1–15. 151, 144, 75,
98, 154

Column 9
Front 1898. 1–15. 71, 17, 61, 31, 27; Left 1898. 1–15. 33, 170, 178, 179,
74; Rear 1898. 1–15. 94, 90, 104, 92, 114; Right 1898. 1–15. 175, 97

Column 10
Front 1898. 1–15. 4, 10, 12, 111, 126; Rear 1898. 1–15. 22, 59, 41, 113, 20

The sources of these plaques are as follows:
1898. 1–15. Foreign Office; 1898. 12–11, purchased; 1901. 4–20,
C. H. Read Esq; 1903. 10–22, E. J. K. Cordner Esq; 1908. 12–5, H. N.
Thompson Esq; 1944. Af 4, Mrs H. G. Beasley

Transference of designs from one medium to another
Ivory staff with cup at upper end 1939 Af33 1
Another (but with a silver cup fitted) 1949 Af46 170
Similar object in bronze; Mrs H. G. Beasley 1944 Af4 21
Ivory cup 1930 6–16 1
Another 1958 Af10 1
Similar in bronze 1949 Af46 162

Shield-shaped plaques
Bronze plaque 1900 7–20 2
Another (cast in 1897); Sir Ralph Moor 1899 6–10 2
Another NN

Miscellaneous works of art
Tusk's head staff top 1959 Af14 1
War-game piece; Mrs A. W. F. Fuller 1962 Af10 1
Miniature elephant; Mrs E. H. Spottiswoode 1947 Af14 1
Ivory kneeling female figure 1949 Af46 169
Ivory divination baton; Mrs H. G. Beasley 1944 Af4 60

Chiefs' altars
Wooden male head 1965 Af15 1
Another 1900 7–20 6
Another 1904 10–18 3
Another; obtained by donor from a shrine in the house of the Iyase
Obaseki of Benin City when converted to Christianity in 1917; H. M.
Brice-Smith Esq 1939 Af7 32
Wooden ram's head 1956 Af27 294
Wooden cock 1949 Af46 175
Wooden altar piece; Wellcome coll 1954 Af23 295
Base for the altar piece 1948 Af2 11
Ivory tusk mounted on the altar piece; Wellcome coll 1954 Af23 407
Bronze head 1952 Af30 1
Wooden *ekpo* mask NN
Small bronze figure; Wellcome coll 1954 Af23 283
Another 1920 11–6 8
Bronze horse-head box 1950 Af20 1
Wooden antelope-head box; Wellcome coll 1954 Af23 309
Another 1897 500
Earthenware pot 1948 Af2 12
Wooden staff; Wellcome coll 1954 Af23 358
Another 1964 Af2 39
Another 1965 NN
Two others 1970 Af23 1, 2
Carved wooden lintel; Wellcome coll 1954 Af23 314

Plinths surrounding courtyard
Circular wooden stool; Mrs H. G. Beasley 1944 Af4 72
Rectangular wooden stool 1898 6–30 2
Another 1954 Af11 3

Another 1949 Af46 174
Wooden chest 1957 Af11 1

Wooden boxes
Box and lid; Capt A. W. F. Fuller 1948 Af34 1
Another; Wellcome coll 1954 Af23 305
Lid only 1897 514
Another 1944 Af4 70
Another 1897 513
Another; Wellcome coll 1954 Af23 307

Ife
Bronze head; National Art-Collections Fund 1939 Af34 1
Terra-cotta head; H. G. Ramshawe Esq 1934 7–16 1
Terra-cotta fragment of a hand; E. J. Hook Esq 1959 Af20 1
Another; H. T. B. Drew Esq 1929 5–7 1
Quartz stool; Sir Gilbert Carter 1896 11–22 1
Fragment of a glass-making crucible; H. T. B. Drew Esq 1929 5–7 2
The seated figure of Tada, at first in the original by permission of the
Director of Antiquities, Nigerian Museum, Lagos, and later in replica.
Casts of several other antiquities of Ife.

The Nok Culture
Casts of Nok Culture terra-cottas.

The Bini-Portuguese ivories
Salt cellar 1878 11–1 48
Another 1879 7–1 1
Another NN
Side-blown horn 1959 Af14 2
Spoon 9184
Another; Sir A. W. Franks (1872) NN
Another; Sir A. W. Franks +5929
Another; Sir A. W. Franks (1873) NN

The Lower Niger Bronze Industry
Standing figure from Tada, exhibited at first in the original, by
permission of the Director of Antiquities, Nigerian Museum, Lagos, and
later, it is hoped, in replica
Figure of a standing woman, from Bida 1949 Af46 178
Pectoral plaque; Mrs Webster Plass 1965 Af1 1
Hunter with antelope 1952 Af11 1
Head; Mrs Webster Plass 1956 Af27 224
Staff top with warrior 1967 Af6 1
Bowl with open-work stand; Christy Trustees 1963 Af1 1
Large bell 1954 Af2 1
Head with tall spout 1949 Af46 155
Ram-headed aegis excavated at Apapa, Lagos, and associated finds
Seated figure from Allabia, Andoni, with two feline skulls in bronze, a
bronze horn, a bell, and two large manillas; Govt of Southern Nigeria
1905 4–13 60, 61, 62, 64, 63, 213
Five bell-heads, two bells, a bronze feather, three armlets and three large
manillas, dug up by the Foreados River; Lady MacDonald 1911 8 11
1–16
Another 1911 12 7 1
Six horned bell-heads 1949 Af7 3–8
Pendant mask 1964 Af6 1
Mask; Lady Epstein 1962 Af13 1

Two bells NN
Two armlets 1928 1 12 2a, 2b
Another NN
Bronze baton 1949 Af46 185
Five bronzes from Igbo-Ukwu; F. W. Carpenter Esq 1956 Af15 1–5

Yoruba

Pair of wooden doors and a lintel, by Olowe of Ise, Ikere-Ekiti 1925 NN
Wooden veranda post, Efon-Alaye, possibly by Ologunde
1949 Af46 147
Another, by Agunna of Oke Igbira; Wellcome coll 1954 Af23 204
Another, Efon-Alaye, by Adetoyin 1959 Af19 91
Another, Efon-Alaye, probably by Ologunde; Mrs C. E. Brumwell
1960 Af16 1
Bead embroidery headdress figure, Ikere-Ekiti 1925 NN
Bead embroidery crown, Epe-Ijebu; Sir William Macgregor
1904 2–19 1
Another, Efoin (=Ifonyin, Dahomey?); E. J. G. Kelly Esq. 1926 10–2 1
Seven others; Wellcome coll 1954 Af23 248, 249, 250, 259, 260, 261, 262
Bead embroidery staff; Wellcome coll 1954 Af23 253
Bead embroidery fly switch; E. J. G. Kelly Esq 1926 10–2 2
Bead embroidery fan; T. R. Sneyd-Kynnersley Esq 1947 Af33 3
Pair of bead embroidery boots, Epe-Ijebu; Sir William Macgregor
1904 2–19 1
Ivory ewer set with European mounts, Owo 1929 30
Ivory double armlet, Owo 1920 11–2 1
Another 1968 Af16 1
Ivory lid, Owo 1876 11–1 32
Ivory pedestal bowl, Owo; Sir A. W. Franks +866
Ivory armlet, Owo 5111
Ivory sword-shaped staff, Owo; Sir A. W. Franks +897
Wooden drum (agba) for Ogboni Society, Ijebu 1949 Af46 146
Another, R. C. Nicholson Esq. 1943 Af3 1

Zimbabwe

Soapstone figure 1923 6–20 1
Soapstone pillar
Archaeological material: glass and shell bead series; British Association
1933 10–9 36
A number of casts of objects not in the British Museum collections are
also included, among them a soapstone pillar surmounted by a bird,
and a figure (in the Tishman collection)

Ashanti

Bronze vessel with lid, kuduo 1903 7–17 1
Another; Mrs C. Chater 1948 Af21 26
Another; Mrs Webster Plass 1956 Af27 42
Bronze ewer, English with badges of Richard II, from Kumasi
1896 7–27 1 Lent by the Department of Mediaeval and Later
Antiquities
Another (lid missing) 1933 2
Silver punch bowl 1933 3
Gold snail shell 1900 4–27 10
Knife with gold sheath, chains and pendants 1900 4–27 9
Cap with gold (wood with gold foil) ornaments 1900 4–27 1
Sword with fur scabbard, gold snake and other embellishments
1900 4–27 7
Filigree pendant in the form of three fish 1900 4–27 44
Gold necklet H. C. Ash 1

Six gold discs H. C. Ash 12, 15, 16, 17, 18, 24
Two others 1900 4–27 11, 25
Another 1942 Af9 1
Gold ornament 1874 5–21 5
Three others of different shapes 1900 4–27 33, 34, 36
Gold vase 1902 11–15 1
Gold pipe bowl, and stem with gold embellishment NN
Two caps, one decorated with gold, the other with gold and silver NN
Umbrella top in form of four birds, wood with gold foil applied NN
Wood chair with stool placed on it; Mrs C. Chater 1948 Af21 113
The stool NN
Two bronze bells; Captain R. P. Wild bequest 1947 Af13 43, 44
Wood stool; Major Kingsford 1953 Af5 1
Iron sword 1896 5–19 4
Another
Human cranium drinking cup: J. M. Post Esq 1874 5–28 1
Ivory horn with human jaw bones; T. Whitfield Esq 1840 5–1 1
Adinkira cloth, collected by T. E. Bowdich NN
Kente cloth (displayed with the stools); Capt R. P. Wild 1937 10–2 2

Bakuba

Wooden figure of King Shamba Bolongongo (c 1600); E. Torday Esq.
(This figure will be displayed first in The Tribal Image and
subsequently in Divine Kingship.) 1909 12–10 1
Wooden figure of King Bope Pelenge (c 1790) 1909 5–13 1
Another, of King Misha Pelenge Che (c 1810) 1909 5–13 2
Wood stool 1909 5–13 3
Wood seat or bench 1909 5–13 4
Wood backrest 1909 5–13 9
Ivory tusk 1909 5–13 12
Wood vessel 1909 5–13 22
Sacred basket 1909 5–13 89
Wood drum. 1909 5–13 265
Wood cup in the form of a horned head 1949 Af46 410
Embroidered raphia cloth, Bambala subtribe 1909 5–13 413
Two raphia cloths with embroidered pile, Bashobwa subtribe
NN (c 1896); 1948 Af32 12

Raphia pile cushion, Bakongo, from the Kingdom of Kongo, collected
before 1774 2822

Cameroon Grasslands

Wooden doorway in four interlocking sections, Bamileke (?)
Wooden throne, Babanki 1969 Af13 1
Wooden bed, Bamenda; Mrs Webster Plass 1957 Af3 69
Wooden mask, Bamum 1943 Af6 1
Another; Mrs Webster Plass 1956 Af27 235
Two wooden figures, Bamileke; Mrs Webster Plass 1954 Af12 1, 3
Two pairs of wooden house posts, Mbum; J. H. H. Pollock Esq
1968 Af6 1–4
Two pipes, with brass and pottery bowls respectively, Bamenda
1948 Af40 6, 7
Drinking horn, Bamenda 1945 Af7 1
Calabash vessel and stopper covered with beadwork embroidery;
Bamileke 1928 8–8 1
Another, Bali 1948 Af40 4
Another, Bamum; Wellcome coll NN
Calabash in basketry harness, Bamileke 1937 2–27 36
Basketry vessel, Bamileke 1937 2–27 37

Bibliography

a. Benin

R. E. Bradbury, *The Benin Kingdom and the Edo-Speaking Peoples of South-Western Nigeria*, Ethnographic Survey of Africa (London 1957)

R. E. Bradbury, 'Chronological problems in the study of Benin History', *J. Hist. Soc. Nigeria*, Vol I, 4, 1959, pp 263–87

R. E. Bradbury, 'Ezomo's *Ikegobo* and the Benin Cult of the Hand', *Man*, Vol LXI (1961), article 165, pp 129–38

R. E. Bradbury, 'The Kingdom of Benin' in *West African Kingdoms in the Nineteenth Century*, ed. D. Forde and P. Kaberry (London 1967)

Philip Dark, *Benin Art* (London 1960)

J. U. Egharevba, *A Short History of Benin*, 3rd edition (Ibadan 1960)

William Fagg, *Nigerian Images* (London 1963)

F. von Luschan, *Die Altertümer von Benin*, 3 vols (Berlin 1919)

C. H. Read and O. M. Dalton, *Antiquities from the City of Benin . . .* (London 1899)

H. Ling Roth, *Great Benin* (Halifax 1903)

Leon Underwood, *Bronzes of West Africa* (London 1949)

b. Elsewhere in Africa

Kevin, Carroll, *Yoruba Religious Carving* (London 1967)

William Fagg, *Afro-Portuguese Ivories* (London 1959)

Raymond Lecoq, *Les Bamiléké*, (Paris 1953)

R. S. Rattray, *Religion and Art in Ashanti* (Oxford 1927)

Thurstan Shaw, *Igbo-Ukwu* (London 1970)

Roger Summers, *Zimbabwe: A Rhodesian Mystery* (Cape Town 1963)

E. Torday and T. A. Joyce, *Notes ethnographiques sur les peoples . . . Bakuba: Les Bushongo* (Brussels 1910)

Frank Willett, *Ife in the History of West African Sculpture* (London 1967)